INTRODUCTION

───◆───

The birds in this book range in size from tiny sprites weighing little more than a nickel, to majestic creatures with six-foot wingspans, and geographically speaking, from the backyards of suburban Europe and North America, to the barely explored cloud and rainforests of South America and Papua New Guinea. There are representatives of the birds of every continent, bar Antarctica, and of many of the world's avian families.

What they all have in common, though, is the feeling that even a fleeting encounter with any one of them can create in us. A feeling of serendipity, of unlooked-for good luck.

That, of course, is in part because of their physical beauty, and the sheer variety of fascinating behaviors in which they engage. But more than anything, I've come to realize in a lifetime of watching birds, it's

because of the very obvious but sometimes strangely overlooked fact that birds can fly.

No matter how much you study them, no matter how much you use the knowledge you've accrued to predict their presence at some or other point on the globe, even the smallest of birds have the ability to disappear on a whim and a wing, and conversely to cross your path when you least expect it. The fascination and thrill of birdwatching, whether it's keeping a casual eye on your backyard visitors or trekking into the wilds in search of rare species, is entirely down to that element of randomness, to knowing that what you seek might elude you, but that something equally astonishing will take its place.

So, explore and enjoy this selection of the world's birds, and be prepared to be surprised. Then, go out and find at least a few of them for yourself, and be prepared to be surprised again, and again, and again.

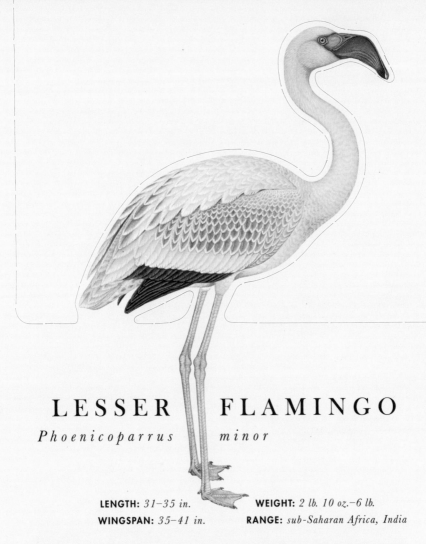

LESSER FLAMINGO

Phoenicoparrus minor

LENGTH: *31–35 in.* **WEIGHT:** *2 lb. 10 oz.–6 lb.*
WINGSPAN: *35–41 in.* **RANGE:** *sub-Saharan Africa, India*

The sight of large flocks of this long-legged, shocking-pink bird strutting about on an African soda lake is an iconic image, but while its world population probably still surpasses two million, it is a species that faces an uncertain future.

Water poisoning and industrial developments at some of its key East African breeding sites, especially Lake Nakuru and Lake Bogoria in Kenya, pose a major threat, because the lesser flamingo needs highly alkaline water, in which its major food source, spirulina algae, grows.

It is photosynthetic pigment in these algae, in fact, that gives the bird its rosy hue, rather than shrimps as is sometimes supposed. But the

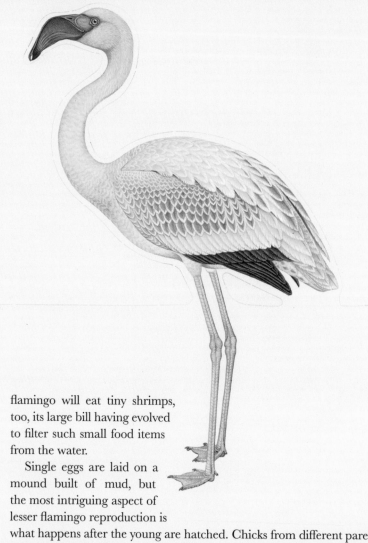

flamingo will eat tiny shrimps, too, its large bill having evolved to filter such small food items from the water.

Single eggs are laid on a mound built of mud, but the most intriguing aspect of lesser flamingo reproduction is what happens after the young are hatched. Chicks from different parents join "crèches," which can sometimes consist of more than 100,000 youngsters, supervised by a relatively small number of adults. These eventually lead the chicks to fresh water, and given that lesser flamingos build their nests as much as 20 miles from their home lakes, that can involve a lengthy trek, during which the birds face predators such as marabou storks, raptors, and baboons.

The lesser flamingo is kept in zoos and collections rather less than the greater flamingo and its close relations the American flamingo and Chilean flamingo, but nonetheless a significant number of captive birds exist.

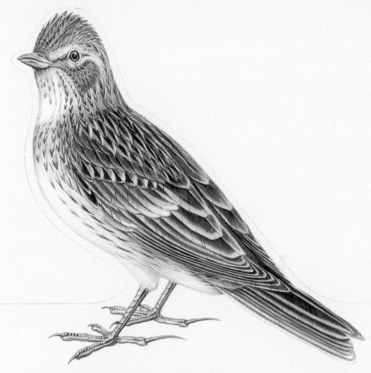

SKYLARK

Alauda arvensis

--- ◆ ---

LENGTH: *6–7 in.* **WEIGHT:** *½–2 oz.*
WINGSPAN: *12–14 in.* **RANGE:** *most of Europe, Asia,*
North Africa

Few species can claim to have made such an impression on human consciousness, while at the same time remaining unrecognizable to the majority of people, as the skylark (or Eurasian skylark, to give it its full name).

Its anonymity is partly down to its relatively unprepossessing gray-brown appearance, which helps to make it inconspicuous on the grassland where it typically feeds and makes its nest.

But even when the skylark is doing what it's best known for—delivering a bubbling, rhapsodic warble that can go on for 20 minutes

unbroken—it generally goes unseen by the casual passer-by, because this extraordinary song is delivered in midflight. The male skylark ascends as high as 330 feet, at which point it is no more than a dot in the sky, before hovering as the song reaches its climax, then descending rapidly to earth.

That song has inspired poets for centuries, most notably Shelley, as well as composers such as Ralph Vaughan Williams, whose "The Lark Ascending" has been repeatedly voted Britain's favorite piece of classical music.

The use of pesticides, and a move toward the sowing of cereal crops in fall, has affected the skylark badly across much of its natural range. Fall sowing means that crops are already too dense in early spring for the birds to be able to forage easily on the ground for insects, on which they feed their young. Additionally, the decreased area of stubble fields in fall reduces the amount of seed food available at that time of year.

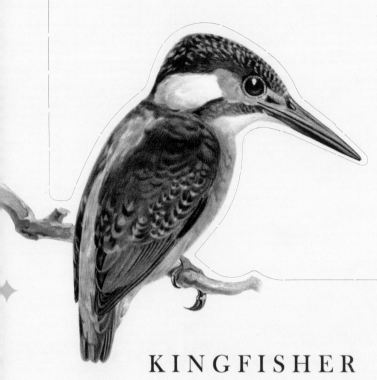

KINGFISHER

Alcedo atthis

---◆---

LENGTH: *7–8 in.* **WEIGHT:** *1–1½ oz.*
WINGSPAN: *10 in.* **RANGE:** *Europe, North Africa, Asia as far east as Borneo*

Strictly speaking, this is the common kingfisher, one representative of a worldwide family of 114 species, but in Europe at least, it remains the kingfisher, one of the few bird species that practically everybody recognizes, and whose fleeting appearance along a river or canal always turns heads.

It typically hunts for minnows, sticklebacks, and other small fish from a perch overhanging water—even somewhere as small as a backyard pond can be used, but the water does need to be relatively clear. The bird catches its prey by plunging headfirst into the water, then returns to its starting point and beats its prey repeatedly against the perch until it's dead.

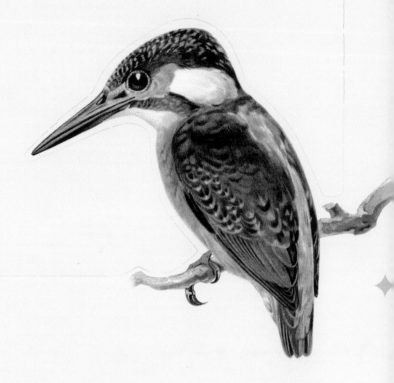

Patience, perseverance, and luck are needed to see all this. Although there are records of kingfishers perching on anglers' fishing rods, for most people the typical sighting is a flash of electric blue as the bird dashes along a river, often accompanied by a repeated shrill whistling.

Even that requires good fortune, because the startling blue on its back is a trick of the light: rather than being due to pigmentation, or genuine iridescence, it's caused by the structure of the feathers, which disperse blue light. Thus a kingfisher seen from the wrong angle can appear a much duller gray-blue and brown bird.

The kingfisher needs rivers and lakes with high, sandy banks to build nest burrows in, and is therefore vulnerable to sudden floods during the breeding season, as well as a number of mammalian predators such as mink. Hard winters in which watercourses are frozen over can reduce numbers also, although in such cases it will migrate in search of warmer areas, and indeed birds in part of the species's range, such as Siberia, habitually do so.

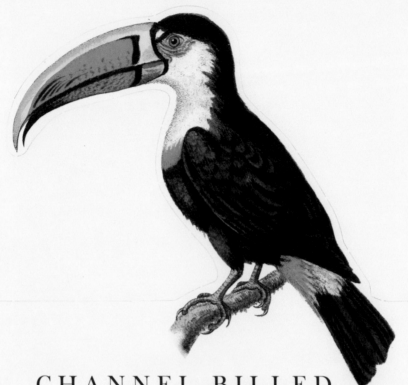

CHANNEL-BILLED
TOUCAN

Ramphastos vitellinus

- - - ◆ - - -

LENGTH: *19–20 in.* **WEIGHT:** *11–15 oz.*
WINGSPAN: *18–22 in.* **RANGE:** *tropical South America,*
Trinidad

Quite why the toucan has such a huge bill has long been a matter for debate. As its diet typically consists of fruit, plus some insects, small reptiles, birds' eggs, and amphibians, the bill may help to reduce energy expenditure, since the bird can reach a greater range of food from a single perch without moving.

It may also act as a deterrent to smaller birds, allowing the toucan to plunder nests and to reach into nest holes, but it probably has little to

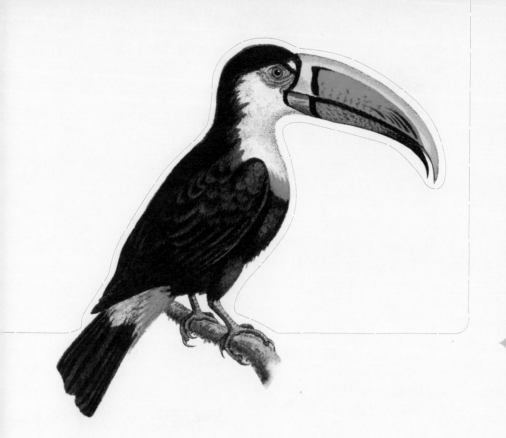

do with sexual attraction, as both sexes have equally large and brightly colored bills. The channel-billed toucan's courtship ritual, in fact, involves the birds tossing fruits to each other.

Recent research has finally revealed that the bill's main purpose is to regulate the bird's body temperature, a valuable asset in its tropical range. The channel-billed toucan prefers the most humid lowland regions, although it can live at up to 5,500 feet and in drier areas, as long as it's close to rivers or other water sources.

The channel-billed is part of a group of species known as "croaking toucans," and its main call is indeed a croaking "krreeeop," repeated several times.

After the breeding season, two or more family groups combine into small flocks, rarely of more than 12 to 15 birds. These may roam locally, but fullscale migrations are not undertaken.

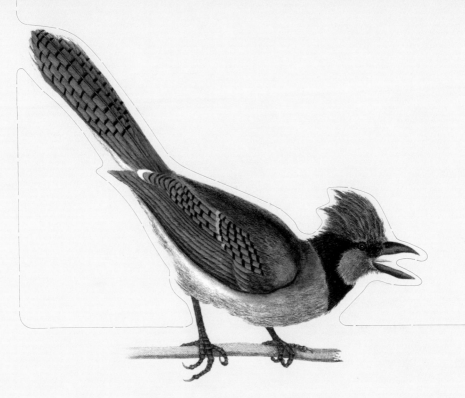

BLUE JAY

Cyanocitta cristata

- - - - ◆ - - - -

LENGTH: *9–12 in.* **WEIGHT:** *2½–3½ oz.*

WINGSPAN: *13–17 in.* **RANGE:** *North America east of the Rockies, including southern Canada*

Historically, this handsome and instantly recognizable species was found only in the eastern two-thirds of North America (the closely related Steller's jay replacing it in the arid pine forest and scrub of the west). In recent decades, however, it has been seen more and more right up to the Pacific coast, and hybridization with the Steller's jay has occurred.

Like most jays, it is omnivorous, with nuts, seeds, and berries making up the bulk of its diet—the former are often cached for eating later. It supplements this with insects and invertebrates, occasional carrion,

bird food taken from feeders, human food scraps, and small numbers of eggs and nestlings of other birds during the breeding season, although, as with its European relative, this seems to be less common than most people and many small birds (judging by their mobbing response to a blue jay) think.

It is also a typical jay in that it is an excellent mimic (it can even be taught human speech), sometimes using this to its advantage, for example imitating common raptors to frighten other birds away from food sources for which it has to compete. More often, its gull-like alarm call is heard, along with a host of other raucous vocalizations.

The blue jay prefers mixed woodland, of not too high a density, so it is perhaps not surprising that it has taken great advantage of manmade environments such as parks, golf courses, and suburban backyards. Young blue jays often steal brightly colored objects such as bottle tops, seemingly out of curiosity—they are discarded after a certain amount of investigation and play.

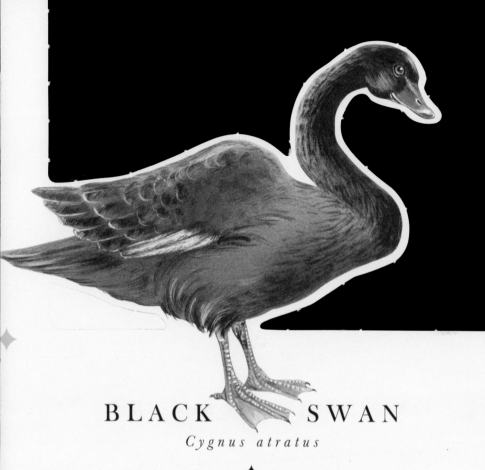

BLACK SWAN

Cygnus atratus

- - - ✦ - - -

LENGTH: *43–56 in.*
WINGSPAN: *63–79 in.*

WEIGHT: *8 lb. 2 oz.–19 lb. 13 oz.*
RANGE: *Australia, New Zealand; introduced/escaped populations in western Europe, U.S., Japan*

The striking appearance of this native of Australasia—mainly black plumage with white flight feathers, and a red bill—made it a favorite species for ornamental collections, and subsequent breeding by escaped birds has created small feral populations in a number of regions.

In its native range, it breeds on fresh, brackish and saltwater lakes, although permanent freshwater wetlands are preferred, and it will travel a considerable distance to find what it needs, carrying out opportunistic migrations in response to drought, food shortages, and

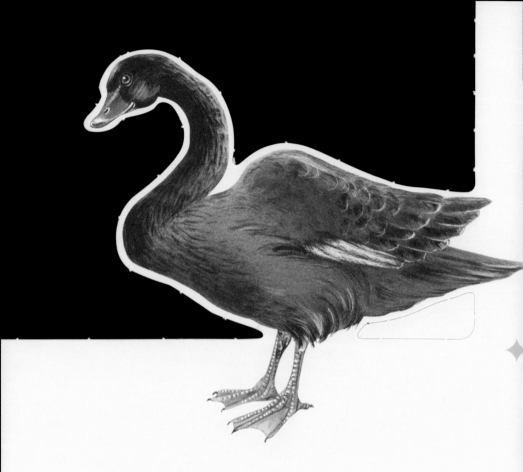

rainfall. During years of heavy rain, it will sometimes move well into the interior of Australia, away from its southwestern and southeastern strongholds.

Its diet consists mainly of aquatic vegetation, but at times it will graze on shore plants also. Like most swans, it's monogamous, with both parents building the nest, incubating the eggs, and sharing the care of the youngsters. Also like most swans, it can be highly aggressive in defense of its nest and young, using its wings and beak to attack anyone or anything that gets too close.

A subspecies of black swan did occur naturally in New Zealand, but was hunted to extinction, before the species was reintroduced in the middle of the nineteenth century. It now thrives there, as in a number of countries. In Britain, it is not yet considered to have a self-supporting population, but with more than 40 birds recorded at the last count, that day may not be too far away.

SUN CONURE

Aratinga solstitialis

- - - - ◆ - - -

LENGTH: *12 in.* **WEIGHT:** *4–4½ oz.*
WINGSPAN: *57½–64 in.* **RANGE:** *Northern Brazil, Surinam,*
French Guiana, Venezuela

For a species that has long been popular as a cage bird, remarkably little is known about this beautifully marked bird—also known as the sun parakeet—in the wild.

Its preference seems to be for lowland humid forest, especially around forest edges, and it will also live in palm groves, fruit plantations, riverside shrubs, and coastal forests. In all habitats, it feeds on fruits, berries, flowers, seeds and nuts, as well as insects, usually moving around in small flocks of up to 30 birds. As it is a highly social creature, these flocks often stay together throughout the day, with the birds preening

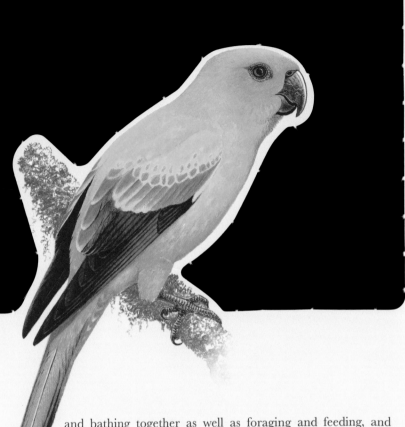

and bathing together as well as foraging and feeding, and moving between different feeding areas with fast, direct flight. It can be a very noisy species, with birds staying in contact by means of continual shrill, high-pitched calls.

Like many parrots, it is able to use its beak as a third foot when it is climbing through the tree canopy in search of food, as well as to manipulate objects and hold food items.

When kept in captivity, the sun conure can live for around 30 years, but historically it has not been as popular as some other parrot species for the pet trade. This is because of its noisiness and highly inquisitive nature, and, although it can mimic human voices, it is not as adept at this as some. Nevertheless, trapping of the species for captivity, and for its vivid plumage, along with considerable loss of its natural habitat, have reduced numbers in the wild and seen the bird officially classed as Endangered on the International Union for Conservation of Nature (IUCN) "Red List," the international index of conservation concern.

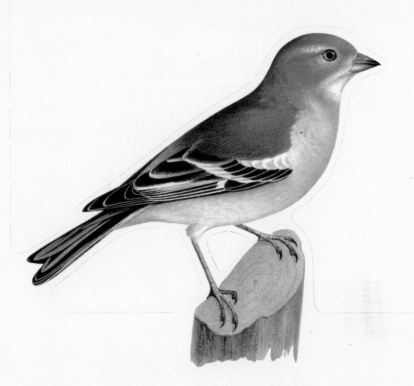

CHAFFINCH

Fringilla coelebs

- - - ◆ - - -

LENGTH: *5½–6¼ in.* **WEIGHT:** *½–1 oz.*
WINGSPAN: *9½–11¼ in.* **RANGE:** *Europe, northwest Africa, parts of Siberia*

Throughout much of western Europe, the chaffinch is one of the most numerous and commonly seen birds, found everywhere from upland forests to city-center parks, although it has a preference for more open vegetation.

Perhaps familiarity with it has bred a certain amount of contempt. Taken in isolation, the male chaffinch is a beautiful bird, with rosy-red underparts, blue-gray upperparts, bright white wing flashes, and a gray-green rump. The females are a duller mix of grays and browns, but no less smart. Add to that a tirelessly bright, if rather metallic and

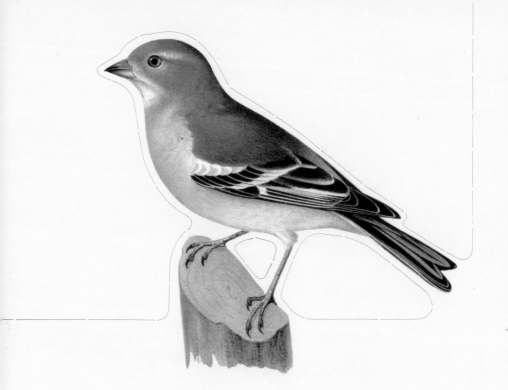

rattling, song, and you have a species that is difficult to ignore.

Studies of chaffinch song have revealed that young males learn it from their fathers during a short period after hatching and, even more intriguingly, chaffinches have been shown to have distinct dialects. It is thought that females look for males who sing significantly differently to the females' fathers, thus reducing the risk of inbreeding.

The bird's sharp "fink!" flight call is thought to be responsible for its British folk name of "spink" and, going much farther back, may also have inspired the Anglo-Saxon *finc*, from which we derive finch.

As well as catching small insects on which to feed its young, it typically forages on the ground for seeds, but in many parts of its range has benefited from backyard feeders. In winter it forms loose flocks and, like most finches, will join mixed-species flocks too.

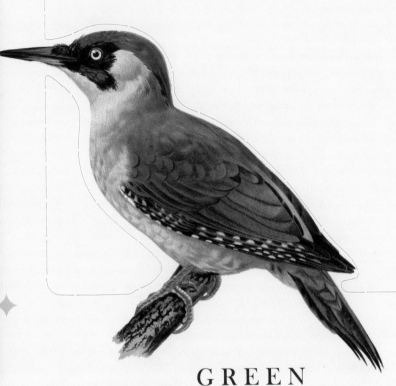

GREEN
WOODPECKER

Picus viridis

- - - - ◆ - - - -

LENGTH: *12–14 in.* **WEIGHT:** *6⅓–7¾ oz.*
WINGSPAN: *18–20 in.* **RANGE:** *Europe*

More than a few people take this colorful backyard visitor for a parrot the first time they see it hopping around on their lawn, so vivid is the impression made by its bright red cap, green upperparts, and yellow-green rump. Discovering its true identity renders it no less striking, or strange.

That's because although it needs deciduous trees, particularly oaks, in which to nest, it's not tied to actual woodland like most woodpeckers. Instead it fills its own evolutionary niche of snaffling ants on rabbit- and sheep-cropped turf with the help of a barbed tongue so long that it wraps

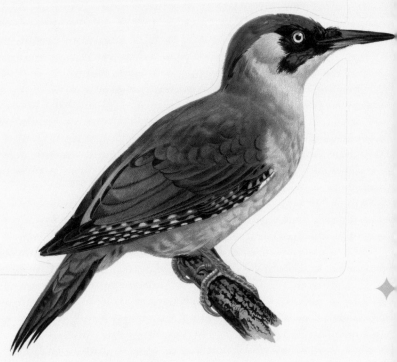

the whole way around the bird's brain.

If disturbed on the ground, it freezes with bill pointed skyward, which, combined with its pale, unblinking eyes, gives it a distinctly reptilian air. But despite this typical sunworshipping pose, this bird is traditionally associated with bad weather, having formerly been known as a "rain bird," due to a supposed talent for weather forecasting. In fact, there's nothing to suggest that it's any more sensitive to changes in conditions than most birds, but its reputation as an augur is a vague memory of its importance in the ancient Mediterranean, where it enjoyed a semi-divine status because of that strong association with the oak, itself a sacred tree.

The green woodpecker "drums" very rarely, usually when excavating nest holes, but still makes itself heard frequently, with its high-pitched, far-carrying, slightly maniacal and mocking "laughter" being onomatopoeically responsible for another of its old folk names—Yaffle.

Found across Europe, except for areas of the far north and east (plus, oddly, Ireland), it's at its most numerous in France, Germany, the UK, and Spain—the subtly different birds in the latter have recently been "split" to form a new species, the Iberian woodpecker *(Picus sharpei)*.

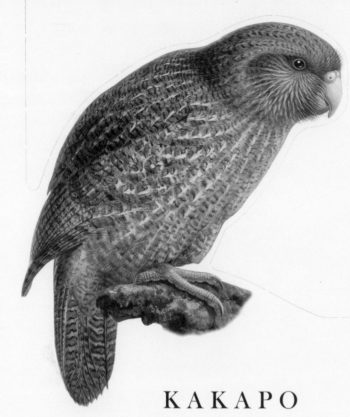

KAKAPO

Strigops habroptila

--- --- ◆ --- ---

LENGTH: *23–25 in.* **WEIGHT:** *2 lb. 1 oz.–8 lb. 14 oz.*
WINGSPAN: *not applicable* **RANGE:** *New Zealand*

Flightless, nocturnal, and with an owl-like face, the kakapo isn't exactly what you think of when you hear the word "parrot." But this species, endemic to New Zealand, is perhaps the most celebrated parrot species in the world at present, because its very survival hangs on a knife-edge.

Originally common and widespread throughout the forests of New Zealand, it started to suffer following the arrival of European settlers, who brought with them mammalian predators such as cats. Numbers fell until, in the mid-1990s, there were only around 50 birds left, a barely

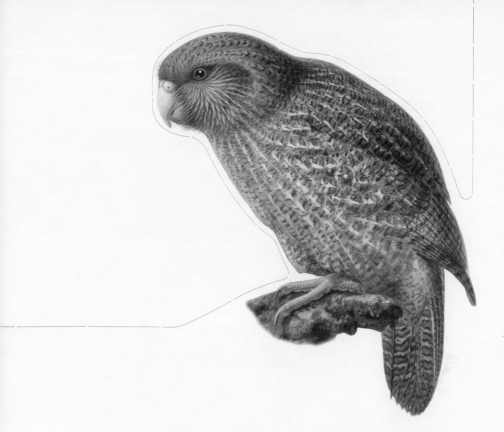

viable population. Since then, conservation efforts have concentrated on moving kakapos to certain predator-free offshore islands, and there is hope that the species may eventually be out of danger—at a recent count, there were 154, so it is likely to be a slow process.

Breeding takes place only when there is a high abundance of fruit, the bird's main food, although it will also eat leaves, buds, flowers, and seeds. Another oddity of the bird is that it is a lek-breeder. The males gather in an "arena" and making loud wheezing calls to attract females, also raising their feathers, spreading their wings, and lifting their claws at each other —it isn't unusual for such displays to end in full-blown fights. No lasting pair bond is formed, with males and females meeting only to mate, and this takes place only every five years or so, another factor that makes the small surviving population extremely vulnerable. The kakapo also has a loud booming call, and both sexes make high-pitched screeching noises.

Kakapos climb trees relatively well, but cannot fly, instead using their short wings for balance and for controlling their falls from trees, although they spend much of their time foraging on the ground.

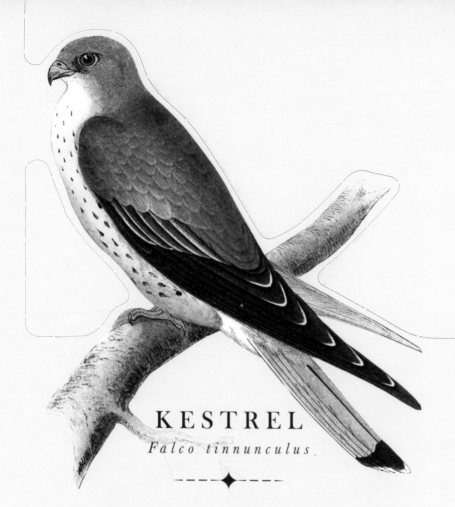

KESTREL

Falco tinnunculus.

---◆---

LENGTH: *12½–15⅓ in.* **WEIGHT:** *5½–3 oz.*
WINGSPAN: *25½–32⅓ in.* **RANGE:** *Europe, western Asia*

The cruciform shape of a hovering kestrel, and the species' historic ubiquity across Europe, makes it the most instantly recognizable bird of prey—you don't have to be a birdwatcher to have noticed it suspended over the verges of roads, motionless but for occasional flickers of its long, narrow, pointed wings.

These movements serve to propel the bird forward at exactly the same speed as the wind into which it is facing, enabling it to remain over the same spot and, crucially, to keep its head absolutely still as it scans the ground below for the small mammals and large insects that make up its diet. Its actions once it finds prey are equally distinctive—folding its

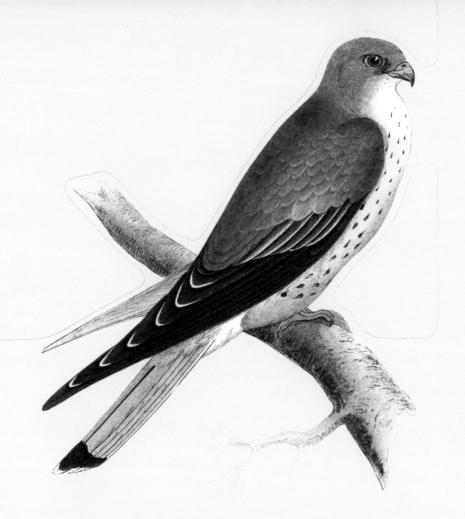

wings and dropping like a stone, before pulling up and hovering again, a maneuver repeated two or three times before the unfortunate victim is finally grasped.

A willingness to live anywhere from city-center parks to uplands is one reason why the kestrel has historically been so widespread and numerous—across Europe, it's only generally absent at really high altitudes—but the species has declined in numbers in the last 20 years, for reasons that may be connected to intensive agriculture reducing prey numbers.

Nevertheless, it remains a familiar sight, if not hovering, then perched aloft with its tail curved down under its body, a comma silhouette punctuating many a long road trip.

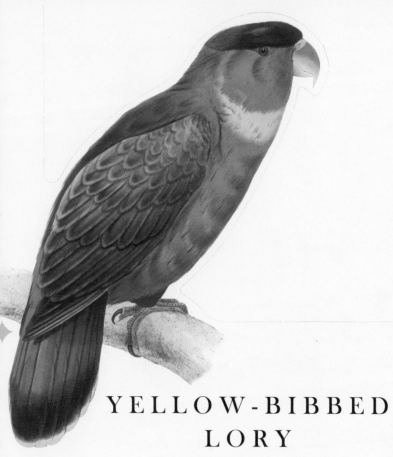

YELLOW-BIBBED LORY

Lorius chlorocercus

– – – ◆ – – –

LENGTH: *11 in.*　　**WEIGHT:** *7 oz.*
WINGSPAN: *67 in.*　　**RANGE:** *Solomon Islands*

A particularly vibrantly colored member of a family that includes a number of other multi-colored gems such as the rainbow lorikeet, the yellow-bibbed lory is restricted to the Solomon Islands of the southwest Pacific, where it is found in forests up to 3,300 feet, and occasionally in coconut plantations. It is most common in mist forest, rather than the lowlands.

In fact, in bright sunshine and against a forest canopy, or a sun-dappled floor, it can be remarkably hard to see, with the bright and contrasting

plumage acting as a "dazzle pattern," breaking up the outline of the bird. The best chance of seeing it, then, is in flight, when its rather stout build and short tail are more obvious thanks to its bright colors.

Usually seen singly, or in pairs, small groups of around 10 birds occasionally form to forage for food, usually pollen, nectar, fruits, small seeds, and a few caterpillars.

Its main calls are a shrieking "chuiick lik" and several similarly harsh, abrupt sounds, but, like many parrots, it is also an excellent mimic and can be trained to talk—historically making it a popular bird for the cage bird trade. While feeding it makes a soft chattering noise.

The current population, however, is as much as 50,000, so while its range is restricted, it is not currently contracting, and any decline in numbers has been small, so the species faces no immediate conservation concerns.

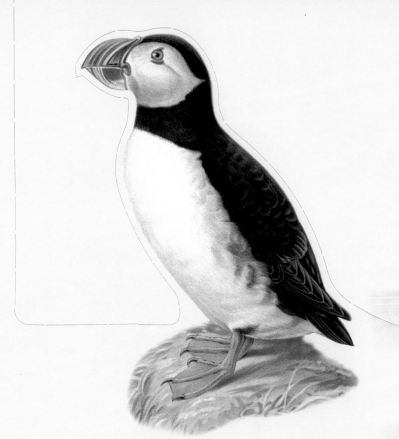

ATLANTIC PUFFIN

Fratercula arctica

- - - ◆ - - -

LENGTH: *11–12 in.* **WEIGHT:** *14 oz.–1 lb. 7 oz.*
WINGSPAN: *18½–25 in.* **RANGE:** *coastal Canada, Greenland,*
 Iceland, Britain, Scandinavia

Considering that it spends well over half of every year way out in the North Atlantic, far from any human contact, the Atlantic puffin is a remarkably familiar bird even to non-birdwatchers.

That, of course, is down to its utterly distinctive appearance, with its large colorful bill having formerly given it the folk name "sea parrot," and its rather comical behavior when it is at its breeding colonies, where it nests in burrows created in clifftop turf. Birds there walk with a distinctly

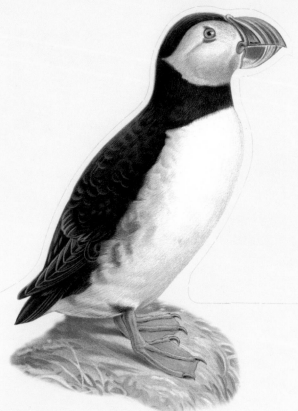

nautical rolling gait.

The adults range far and wide each day in search of sand eels and other small fish, flying fast, low, and directly on whirring wings, or swimming strongly on even the choppiest waters. The classic image of the bird is of one returned to the burrow with a beak full of fish—it is able to hang on to several while catching others.

In recent decades, numbers have dropped in many areas, probably due to a lack of food because of climate change and prey species being inadvertently caught by trawlers. But hunting has also played a part, in some populations at least, as puffins have long been harvested for food in places such as the Faroe Islands and Iceland, where more than 60 percent of the world's puffins breed. Hunting is now only permitted in the latter at a sustainable level.

Puffins also face predation from seals and sea mammals, and egg predation from mammals such as rats and foxes, as well as parasitism from large gulls and skuas, which force them to disgorge their catch and so render the task of feeding a burrow full of young that much more taxing.

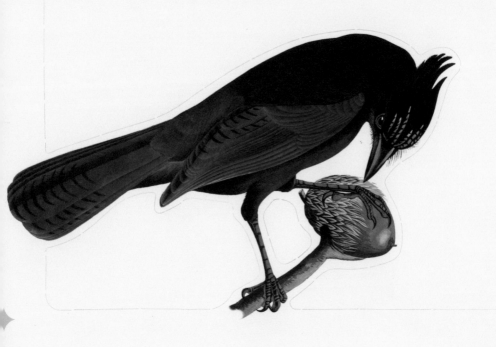

STELLER'S JAY

Cyanocitta stelleri

---◆---

LENGTH: *11½–13½ in.* **WEIGHT:** *3½–5 oz.*
WINGSPAN: *16½–19 in.* **RANGE:** *western North America*

This handsome species is restricted to the far west of North America, living in coniferous and mixed forests, although in the southwest of its range it will also use arid pine-oak woodland, building nests in conifers or occasionally utilizing tree holes and hollows.

In such a shadowy habitat, its plumage can be remarkably inconspicuous, but seen on a suburban lawn—and Steller's jays will readily live in close proximity to humans—it is striking and memorable, with the dark head (streaked with blue) giving way to blue tones that lighten the farther down the bird you go. In the more southerly part of its range, the head is lighter and bluer, but all populations show a prominent crest.

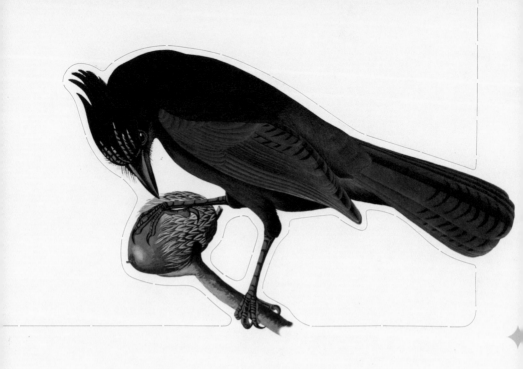

Steller's jay is a little larger and longer-legged than the blue jay, which replaces it in the rest of North America, but the two are closely related so that hybridization can and does occur.

Like its relative, and most jays, it has a catholic taste in food that is centered on nuts and seeds but also includes invertebrates, small rodents, and reptiles, and the eggs and nestlings of other birds for a short period during the breeding season. As with most jays, food such as acorns and nuts is cached for later consumption.

Again in common with many corvids, it is a gifted mimic of other birds' calls, sometimes imitating the calls of raptors in order to scare competitors away from food sources. Its own calls are a variety of harsh rattles and screeches, plus a rather breathless whistle—one way or another Steller's jays rarely leave you in too much doubt about their presence.

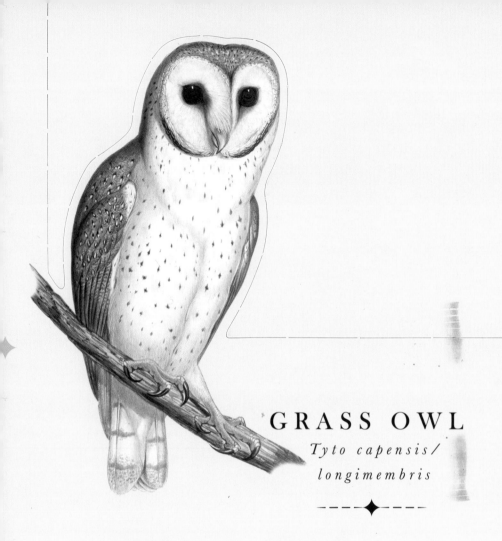

GRASS OWL

*Tyto capensis/
longimembris*

- - - ◆ - - -

LENGTH: *12½–16½ in.*
WINGSPAN: *39–46 in.*
WEIGHT: *14 oz.–1 lb.*

RANGE: *Africa, eastern, southern, and Southeast Asia, New Guinea, Australia, western Pacific islands*

Its heart-shaped face, white underparts and buoyant, silent flight give the grass owl the same ghostly appearance as the widely distributed barn owl, but it is restricted to Africa, parts of Asia, the Pacific Islands, and Australia. Debate continues as to whether there are two species—African grass owl and eastern grass owl—or if these are simply two subspecies of one species, but they share many attributes.

The grass owl is nocturnal, hunting at night in dry grasslands and

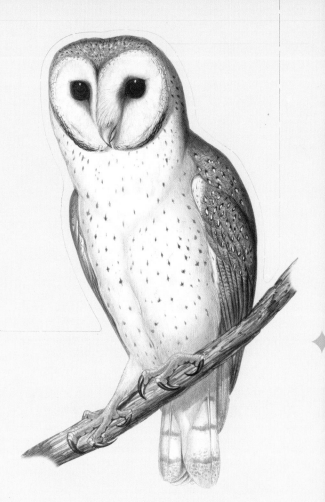

marshes, using its superb hearing and eyesight. Long legs enable it to snatch its prey—almost exclusively small mammals such as voles, rats, and mice—from deep in the vegetation.

During the day, it usually roosts in tunnels and on platforms in the long grass, made by trampling down the surrounding vegetation. Nests, also, are usually created on such platforms. Only in extreme circumstances, such as a dearth of prey or very bad weather making hunting impossible the previous night, will it take to the wing during the day.

Like the barn owl, it is known for its high-pitched screeching and hissing calls, which also contribute to a sometimes eerie reputation.

Populations in some countries, such as South Africa, have fallen in recent years because of loss of habitat, but it is not considered to be threatened globally.

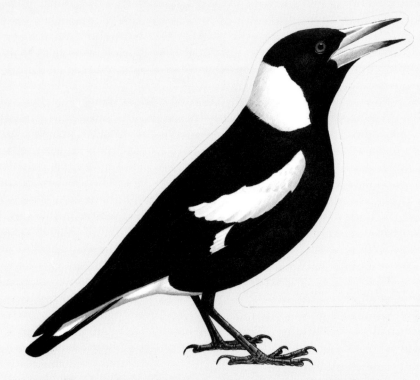

AUSTRALIAN MAGPIE

Gymnorhina tibicen

- - - ◆ - - -

LENGTH: *14½–17 in.* **WEIGHT:** *7¾ –12¼ oz.*
WINGSPAN: *25½–33¼ in.* **RANGE:** *Australia, New Zealand, New Guinea*

Names can rarely be relied upon to tell the full story about a species and there's no better example of that than the Australian magpie. Far from being close to the European magpie or its North American equivalents, which are members of the crow family, it's in a genus all of its own, and is most closely related to the butcherbird, a family of large Australasian songbirds. But it does share the real magpies' striking black-and-white plumage, as well as their boldness and omnivorous diet, and so was named after them by the first European settlers.

It is also similar to true magpies in that it will happily live in close

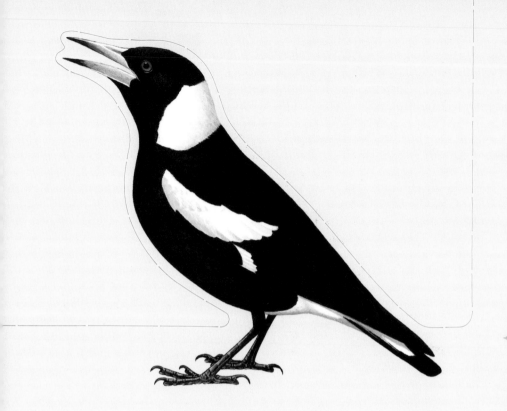

proximity to humans, and do so across its range, which encompasses most of Australia, parts of southern New Guinea, and New Zealand (where it was introduced to help control agricultural pests). This sometimes brings it into conflict with humans, and it's known for its willingness to try to chase away anyone who comes within 100 yards of its nest during the breeding season, giving loud alarm calls, swooping down and snapping its beak, and in some cases pecking at the heads of the intruders. Wide-brimmed hats offer some protection, but as the bird mainly attacks the back of the head, a pair of sunglasses or even a pair of eyes painted on the back of the hat can deter it.

The bird typically lives in flocks, and as it is highly intelligent, it engages in play with others of its species, even using objects such as sticks or rocks.

Its complex, melodious, warbling songs and calls is a constant soundtrack across much of Australia, and so familiar a sound and sight is it that this bird is a popular choice as an emblem for sports clubs.

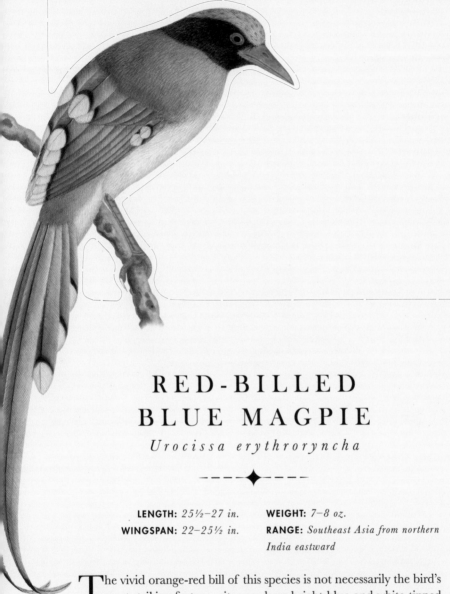

RED-BILLED
BLUE MAGPIE

Urocissa erythroryncha

◆

LENGTH: *25½–27 in.* **WEIGHT:** *7–8 oz.*
WINGSPAN: *22–25½ in.* **RANGE:** *Southeast Asia from northern India eastward*

The vivid orange-red bill of this species is not necessarily the bird's most striking feature—its very long bright-blue and white-tipped tail, one of the lengthiest of any corvid, catches the eye and sticks in the memory every bit as much, putting one in mind of birds of paradise, close relatives of the crows.

An inhabitant of upland evergreen forest and scrub, but also found around the densest and largest of metropolises such as Hong Kong,

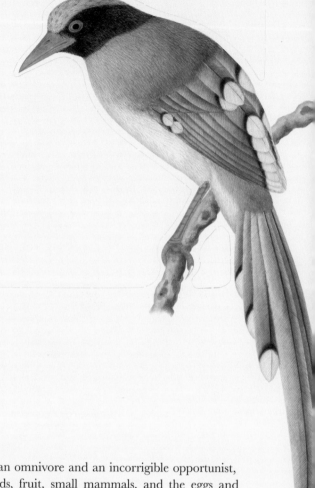

it is, like most magpies, an omnivore and an incorrigible opportunist, eating invertebrates, seeds, fruit, small mammals, and the eggs and young of other birds during the breeding season—as a whole, its diet is more strongly carnivorous than many members of the crow family.

Along with most other corvids, it is noisy and has a great range of vocalizations, from a harsh rattle to a fluting whistle, and it can imitate other birds, animals, and even human speech on occasion.

It is not strictly migratory, but often moves higher into the montane forests during the summer.

Sometimes called the red-billed blue magpie, it forms a "superspecies" with the yellow-billed blue magpie and the Taiwan blue magpie. It is occasionally kept as a cage bird, and escaped specimens have been reported in Britain on occasion.

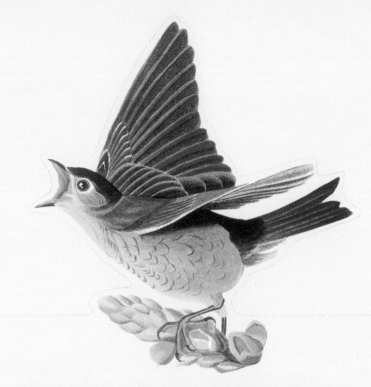

EASTERN BLUEBIRD

Sialia sialis

- - - ◆ - - -

LENGTH: *6½–8½ in.*
WINGSPAN: *10–13 in.*

WEIGHT: *1–7¼ oz.*
RANGE: *North America east of the Rockies, Central America*

This brightly colored species, with its royal-blue upperparts contrasting with an orange-red breast and neck, is a familiar sight in much of North America.

It is often seen sitting on telephone wires or similar perches in open country, singing its melodious but rather wavering song, or looking for insects on which to feed. When it spots a tempting morsel—typically a beetle, cricket, or grasshopper—it drops to the ground to grab it. As a member of the thrush family, it also feeds on snails and earthworms on occasion, while berries and fruits are important food sources in winter.

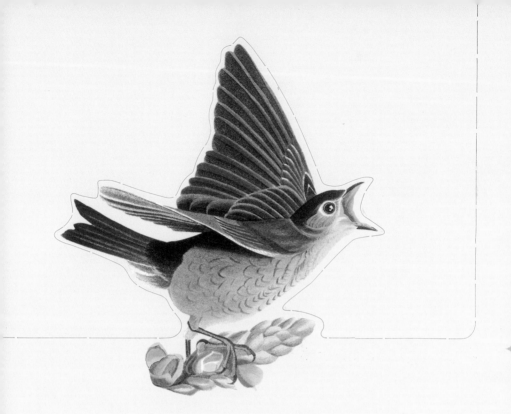

The availability of food determines whether local populations of eastern bluebirds migrate south during the colder months. Some movements can be relatively short-range, while others of the species undertake longer journeys to the area around the Gulf of Mexico. At all times, however, this bird prefers open country with plenty of trees in close proximity, and it has adapted well to use manmade habitats such as parks, golf courses, highway verges, and such like.

The eastern bluebird nests in abandoned woodpecker holes, or natural tree cavities, usually raising two broods a year. It is highly territorial during the breeding season, and some birds continue to defend a feeding territory all year round, but most join forces with others to form large flocks.

Incidentally, it has nothing to do with the bluebirds mentioned in the World War II song popularized by the British singer Vera Lynn—in that case, "bluebirds" is a nickname for the British Royal Air Force. Eastern bluebirds have never been recorded in Europe.

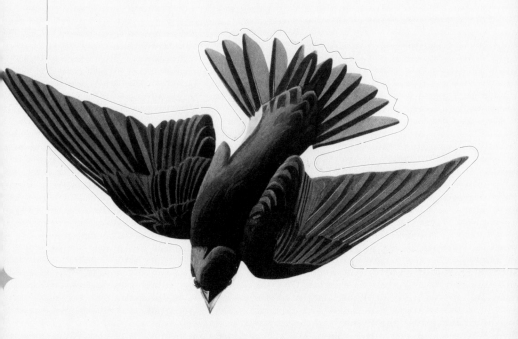

AMERICAN
TREE SWALLOW
Tachycineta bicolor

- - - - ◆ - - - -

LENGTH: *5–6 in.*　　**WEIGHT:** *½–1 oz.*
WINGSPAN: *12–14 in.*　　**RANGE:** *Canada, northern USA;*
migrating to Central America in winter

This little jewel of a bird, with its iridescent blue-green upperparts and notched tail, winters further north than any other American member of the hirundine (swallow and martin) family, and also returns to its breeding grounds long before the rest.

It can do so in part by being able to eat some plant material, as well as the insect prey that makes up the bulk of any hirundine diet, which means that it can survive a cold snap soon after arriving back. It also

eats a wide range of insect prey, from "aerial plankton," no larger than a grain of sand, to dragonflies or beetles up to 2 in. long.

Its prominence as a harbinger of spring has made it a much-studied bird, but relatively little is known about its life on the wintering grounds, or during migration, other than its habit of forming enormous flocks just before dusk each night, with swirling tornadoes of hundreds of thousands of birds gathering above roosting sites before dropping into cover in small groups. Flocks of well over a million have been recorded, and large gatherings also sometimes occur when insect swarms offer an irresistible feast.

The name is a little misleading, as it is most commonly seen in open country, but the moniker comes from the fact that it nests in tree cavities. Although such natural sites have become less common in recent decades, the population remains at a healthy level as it also readily takes to using nestboxes, including those provided for the likes of bluebirds and wood ducks.

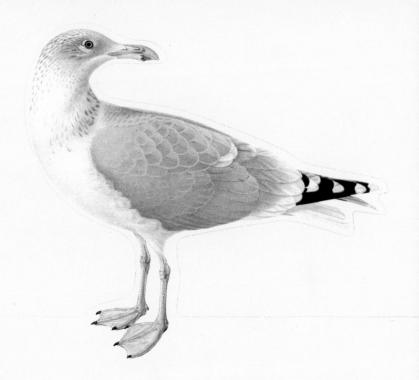

HERRING GULL

Larus argentatus

---◆---

LENGTH: *21–26 in.*
WINGSPAN: *48–59 in.*

WEIGHT: *1 lb. 9 oz.–3 lb. 6 oz.*
RANGE: *northern & western Europe, northwest Russia*

In northern Europe, this is the species that most casual observers will be referring to by the name "seagull," but its behavior and its taxonomy are a great deal more complicated than that simple moniker suggests.

For one thing, while it breeds in coastal areas (including on rooftops), it is—like most gulls—an opportunistic omnivore that will take advantage of any good food source. Because of that, it will travel considerable

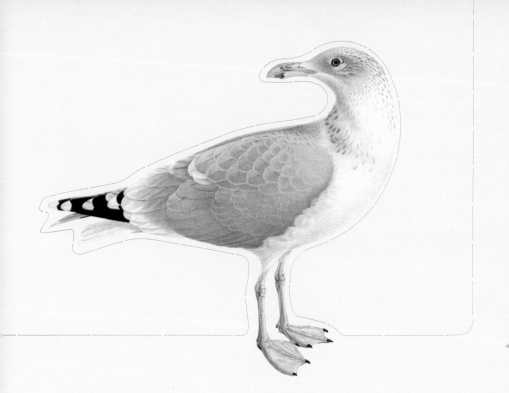

distances inland, especially during the winter, to feed at sewage farms, on inland reservoirs, at landfill sites, and on agricultural land, as well as in the center of even the largest cities. When at the coast, it takes crabs, molluscs, fish, and fish offal (from trawlers), while worms also make up a large part of its diet everywhere. It often attracts these to the surface by pattering its feet on the ground, simulating the sound of rain.

The herring gull is part of a complex family which includes Scandinavian and western European subspecies, as well as closely related species such as American herring gull, Caspian gull, yellow-legged gull, Vega gull, Armenian gull, and lesser black-backed gull. The fact that hybridization can and does occur between some of these just makes the picture even more murky, and science still has much to discover about this particular bird family.

Nevertheless, the herring gull's loud, laughing call is, for most people in northern and western Europe, aural shorthand for a seaside location. Recent population declines are worrying and, as yet, not well understood.

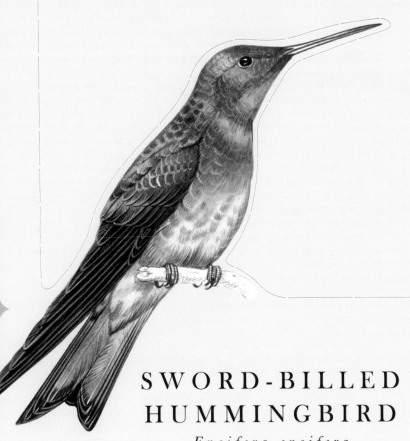

SWORD-BILLED
HUMMINGBIRD

Ensifera ensifera

---◆---

LENGTH: *5–5½ in.* **WEIGHT:** *⅓–½ oz.*
WINGSPAN: *4½–5½ in.* **RANGE:** *Venezuela, Colombia,*
Ecuador, Peru, Bolivia

Not so much a bird as a hypodermic needle with a pair of wings attached, the sword-billed hummingbird is the only bird species in the world with a beak that's longer than its body. Seeing one whirr past in the cloud forests of the Andes, where it is uncommon and unevenly distributed between 5,500 and 10,000 feet, is to suspend belief in the laws of aerodynamics, so obvious does it seem that it should plummet beak-first into the ground, although of course, like all hummingbirds,

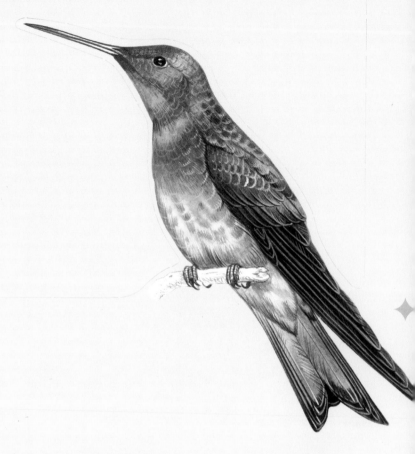

it can both hover and fly backwards, courtesy of wings that beat extraordinarily fast in a figure-of-eight pattern. Also in keeping with all hummingbirds, it has evolved that extraordinary bill, and a long tongue to match, in order to extract nectar from certain species of passionflower, namely those with long corollas. It will visit manmade hummingbird feeders also in some areas.

The size of the bill forces the bird to perch with its head tilted upward to maintain its balance and, unlike most birds, it has to do all its preening with its feet—which, although as effective as using a bill, is a lot more time-consuming.

Only the female birds feed the young at the nest, but both males and females are polygamous, mating with several partners to increase the chances of reproductive success. This is probably an adaptation to the species's sparse and patchy distribution.

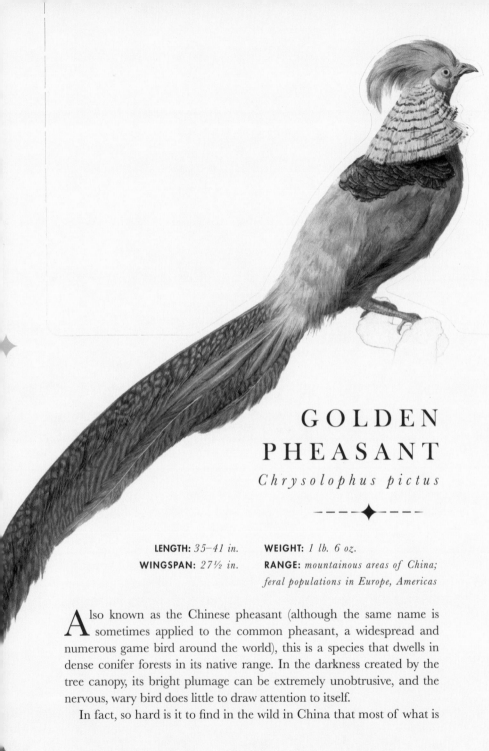

GOLDEN
PHEASANT

Chrysolophus pictus

❖ - - - - ◆ - - - -

LENGTH: *35–41 in.*	**WEIGHT:** *1 lb. 6 oz.*
WINGSPAN: *27½ in.*	**RANGE:** *mountainous areas of China;* *feral populations in Europe, Americas*

A lso known as the Chinese pheasant (although the same name is sometimes applied to the common pheasant, a widespread and numerous game bird around the world), this is a species that dwells in dense conifer forests in its native range. In the darkness created by the tree canopy, its bright plumage can be extremely unobtrusive, and the nervous, wary bird does little to draw attention to itself.

In fact, so hard is it to find in the wild in China that most of what is

known about the species is derived from watching
the feral populations that have sprung up in Europe
and the Americas.

It is reluctant to fly, doing so only rather clumsily and
with a great clatter of wings in extreme circumstances—one
reason why it has never gained popularity as a target of hunters in
the same way as its close relative.

It spends most of its time foraging on the ground for grain and
seeds, berries, and invertebrates, but roosts in trees at night. Because
of its timidity, the best chance to see one is usually by watching forest
clearings at first light, when it throws off some of its caution in order
to feed.

The male's elaborate courtship display includes spreading and
erecting his neck feathers like a cape. This "ruff" is a feature shared
with the closely related Lady Amherst's pheasant, with which it can
hybridize (in captivity, at least).

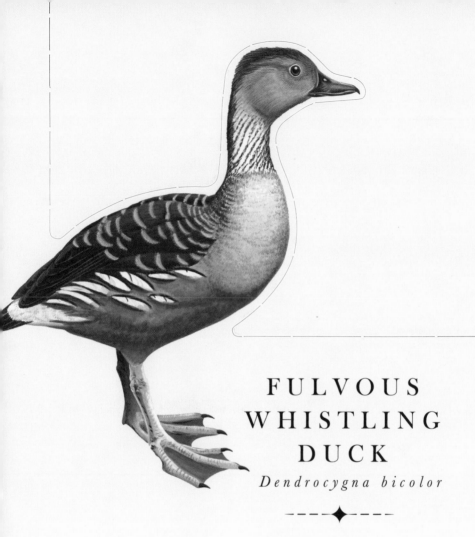

FULVOUS
WHISTLING
DUCK

Dendrocygna bicolor

- - - - ◆ - - - -

LENGTH: *18–21 in.* **WEIGHT:** *1 lb. 9 oz.–2 lb. 5 oz.*
WINGSPAN: *30–37 in.* **RANGE:** *Caribbean, Central & South
America, Africa, Southeast Asia*

Also known as the fulvous tree duck, this is a member of a family of
eight species, which share whistling flight calls, along with a long-
necked, rather hump-backed appearance.

It prefers well-vegetated wetlands and lakes in the lowlands, and so
has taken to using paddy fields in large parts of its range, something that
has brought it into conflict with human populations. Given that it is also
hunted for the pot in many areas, you might expect that it would be

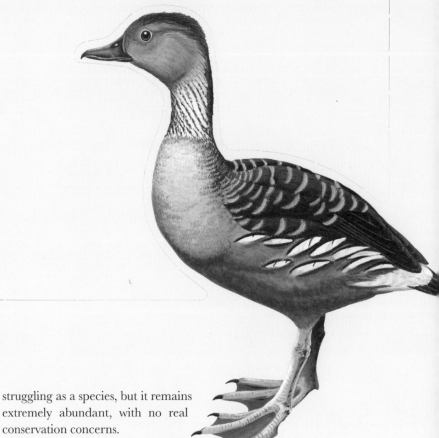

struggling as a species, but it remains
extremely abundant, with no real
conservation concerns.

Like many ducks, it spends much
of the day sleeping or resting,
feeding closer to dawn and dusk, and sometimes at night. The diet is
largely vegetarian, and includes seeds and grasses, but it will also take
molluscs, insects, and worms, especially as it prepares for breeding, when
calcium is needed to form eggshells.

Rice, strangely, seems to form only a very small part of the diet—what
the paddy-field ducks are really interested in, it seems, is the weeds that
grow between the rice plants.

Unlike other whistling ducks, it rarely if ever perches in trees, but,
while nests are usually made in dense vegetation close to water, tree
holes are sometimes used. Pairs normally remain faithful to each other
throughout their lives, and so the species's courtship display is relatively
restrained by the standard of many ducks—the birds bob their heads at
each other, and perform a short "dance" while treading water.

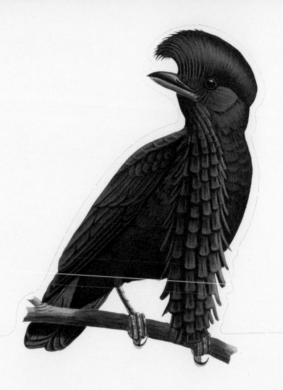

LONG-WATTLED
UMBRELLA BIRD

Cephalopterus penduliger

❖ - - - ◆ - - -

LENGTH: *14–20 in.*
WINGSPAN: *26–28 in.*

WEIGHT: *11 oz.–1 lb. 4 oz.*
RANGE: *southwest Colombia, western Ecuador*

With a crest that resembles the quiff of the young Elvis Presley, a chest wattle that can be shortened at will (it is always retracted during flight) and a smart all-black plumage, this member of the cotinga family is a bird not easily forgotten once encountered, and is one of the largest passerine species in South America.

If its striking appearance isn't enough, during the breeding season the males display that pendulous wattle and raise their crests at leks.

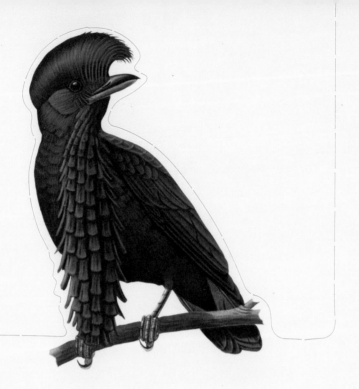

These are gatherings of breeding males for the purpose of impressing females, which are also used as a courtship strategy by many species of grouse, as well as some waders such as the ruff. At leks, the males show off those long, pendulous wattles, which can reach as much as 14 inches long, and sound their resonant, foghorn-like calls (the wattle helps amplify these) across the foothill and lowland forests where they make their home.

Once mating has occurred, a single egg is laid and incubated for almost a month by the female alone. She also cares for and feeds the nestling on her own, providing food on average once per hour, with some of its consisting of material she has regurgitated.

The bird is currently under considerable threat because of degradation and destruction of this habitat, where it feeds mainly on certain large fruits from trees in the palm and laurel families, as well as small numbers of insects and invertebrates. It is considered endangered in Ecuador.

The bird's name, incidentally, is down to the crest, which superficially resembles an umbrella.

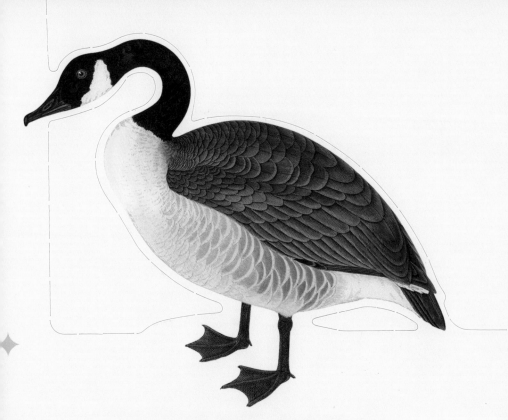

CANADA GOOSE

Branta canadensis

- - - - ◆ - - - -

LENGTH: *30–43 in.* **WEIGHT:** *5 lb. 5 oz.–14 lb. 5 oz.*
WINGSPAN: *50–73 in.* **RANGE:** *Canada & northern USA,*
wintering in southern North America;
also northern Europe, New Zealand

Encountering these large, handsome geese in a park in northern Europe, or increasingly in North America, you could be forgiven for thinking them thoroughly domesticated, so readily do they accept food handouts. Indeed, in some places they have lost their fear of humans to the extent they can be positively aggressive toward them.

But at least four to five million of the world's Canada geese are truly wild birds, breeding on rivers, lakes, marshes, and coastal areas, where they

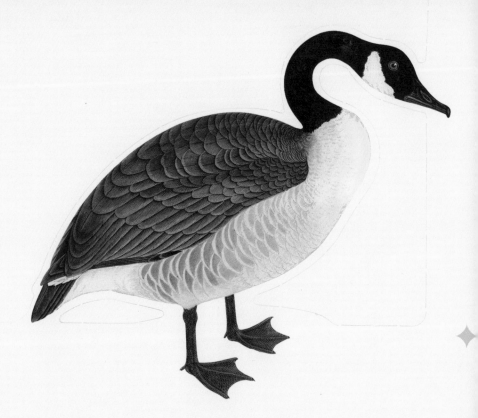

feed on green vegetation, seeds and grains, and a few insects, and small fish. They then carry out long-distance migrations in fall to wintering grounds such as the southern United States and Mexico.

On their travels, they fly in distinctive V-shaped skeins, with different birds taking turns to lead the way, and the following birds deriving aerodynamic benefit by using the lift created by birds in front of them. Such flocks fly at anything up to 3,000 feet, but have been recorded at almost ten times that altitude. Apart from the journey's natural hazards, such as exhaustion and predation by the likes of peregrine falcons, Canada geese are one of the main quarries of human hunters in the United States.

In northern Europe, and warmer parts of the United States where habitat such as parkland and golf courses are available, the birds don't migrate. Some of the European birds, however, which were introduced to ornamental collections from the seventeenth century then escaped and started to breed, are now starting to, either in response to cold weather or in late summer to find safe areas in which to moult.

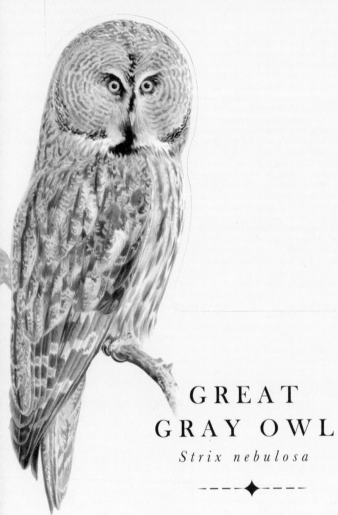

GREAT
GRAY OWL

Strix nebulosa

---◆---

LENGTH: *24–33 in.* **WEIGHT:** *1 lb. 1 oz.–4 lb. 3 oz.*
WINGSPAN: *55–60 in.* **RANGE:** *northern North America,*
northern Europe, Asia

The world's largest owl in terms of length (although several outweigh it), the great gray owl is found throughout the coniferous forests of the northern hemisphere, and will also nest in deciduous woodland in the southern parts of its range.

Like all owls, it has excellent hearing thanks to its facial disc, which helps to focus sound, and the asymmetrical placement of its ears, which helps to locate prey. Hunting takes place mainly at night, dawn

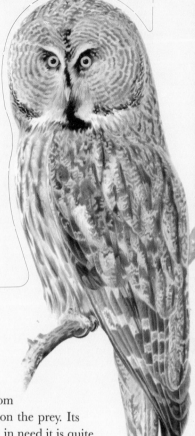

and dusk, with the bird typically listening from a suitable low perch, before swooping down on the prey. Its main target is rodents such as voles, but when in need it is quite capable of taking mammals such as martens and weasels, and birds as large as grouse.

Remarkably, it can use its excellent hearing to find prey moving around under deep snow, plunging as deep as 2 ft. into the snow to capture the unfortunate animal.

Although it is non-migratory, this bird will travel considerable distances in response to food shortages, and as with many members of the owl family, the amount of eggs a female lays is dictated by the availability of prey—thus great gray owl populations can rise and fall in line with fluctuations in the population of their main prey.

Rather than building its own nest, it takes over one abandoned by another large bird, usually a raptor. Unlike many large predators, it is not aggressively territorial except in the immediate vicinity of its eggs or young, and so can go unnoticed by humans even at close quarters.

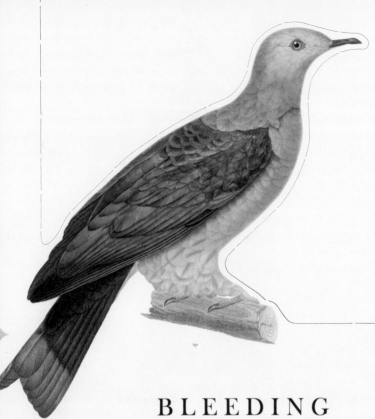

BLEEDING
HEART DOVE

Gallicolumba luzonica

◆

LENGTH: *10–11½ in.* **WEIGHT:** *4½–5 oz.*
WINGSPAN: *14½–15½ in.* **RANGE:** *Philippines*

One of a family of eight species of "bleeding heart doves," so called because the red spot on its breast is supposed to resemble a wound, this dove is endemic to Luzon, the largest and most populous island of the Philippines, with its close relatives distributed throughout the rest of the archipelago, Indonesia, and the southwest Pacific islands.

Of all of these species, this is the one in which the "wound" is largest, extending well down the belly, which has a pinkish hue. Yet equally eyecatching is the plumage of the bird's upperparts, which at first sight

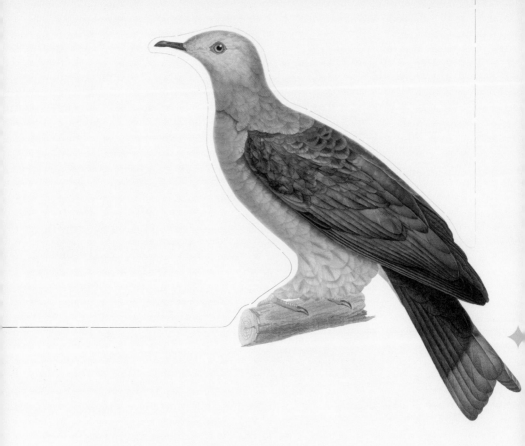

can appear to be a dull slate gray, but can flash an iridescent bottle green, blue, and purple, depending on the way the light catches it.

The "wound" is used during the species's breeding display. It is anyway larger on males than on females, but during courtship the male chases the female with his chest feathers puffed out, so as to fully display the vivid red markings.

Like all of its family, it is a ground-dwelling bird, foraging for seeds, berries, insects, larvae, grubs, and worms on the floor of primary and secondary forests, and usually relying on stealth and its wary, shy nature to avoid predators. Nests are built low down in trees and bushes, and it will also sometimes roost in such vegetation overnight.

The species is currently classed as Near Threatened, due to a drop in numbers caused by deforestation—even where suitable habitat remains, it has often become too fragmented to support viable populations. A captive breeding project is taking place in Australia, with a view to restocking wild populations should it become necessary.

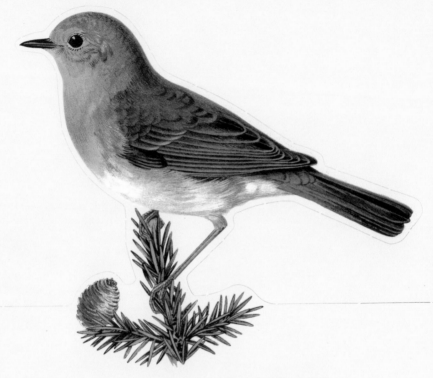

EUROPEAN ROBIN

Erithacus rubecula

- - - ◆ - - -

LENGTH: *5–5½ in.* **WEIGHT:** *½–¾ oz.*
WINGSPAN: *8–9 in.* **RANGE:** *Eurasia, North Africa,*
Atlantic islands

In Britain and northwest France, this diminutive member of the chat family may be the most recognized of all bird species, not least because of its appearance on Christmas cards.

This link only dates back to the mid-nineteenth century, although older legends connect it to Jesus—the bird's breast is said to have been stained with his blood after it comforted him on the cross by singing in his ear. In fact, the Christmas link is more likely to do with Victorian postmen having been nicknamed "robin" because they wore red jackets.

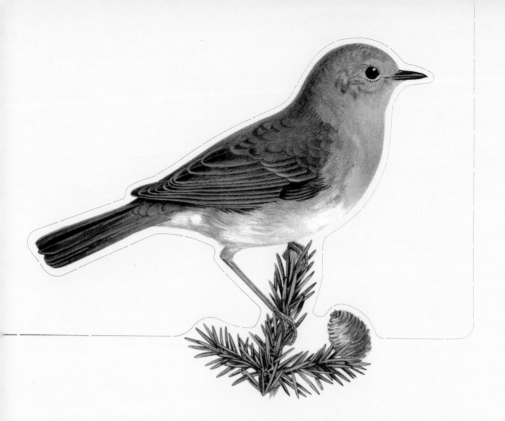

Regardless, the robin is held in great affection in Britain, having recently been voted the UK's National Bird. A major reason is its confiding nature. It will hop around the feet of someone digging their backyard in order to snatch any earthworms turned up—originally, it would have followed large mammals such as wild boar around for the same reason. Insects and spiders are also eaten, plus berries, fruit, and birdtable seed mixes in winter.

Backyards and parks form a major part of its habitat, although the robin is by nature a bird of woodland, and will also use hedgerows and farmland edges.

Elsewhere in its range, it is a much more wary bird, because of historic hunting of small species, but everywhere it is highly territorial, with males sometimes killing rivals during confrontations.

Robins are unusual in that both sexes sing in winter, when the male retains his breeding territory and the female sets up a feeding territory nearby. Singing also regularly takes place at night, leading it to be mistaken for its close relative the nightingale.

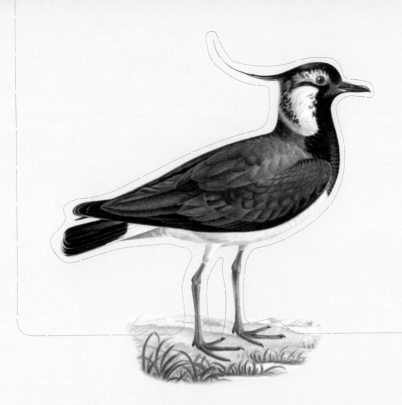

NORTHERN LAPWING

Vanellus vanellus

- - - ◆ - - -

LENGTH: *11–13 in.* **WEIGHT:** *4½–11½ oz.*
WINGSPAN: *26½–34 in.* **RANGE:** *Europe, parts of Asia*

E ven today, when populations have declined due to loss of its preferred breeding habitat of rough grassland, the northern lapwing may be the wading bird most easily recognized by casual birdwatchers— although it's far from the most typical. On close inspection, its pied appearance is revealed to contain glorious green, blue, and purple sheens, it sports a long crest, and its wings are wide and rounded at the tips, rather than pointed like most waders.

The shape of the wings is responsible for the bird's scientific name, which means "little fan," while its British folk name of "peewit" is imitative of its call, but it's hard to say for sure what "lapwing" refers

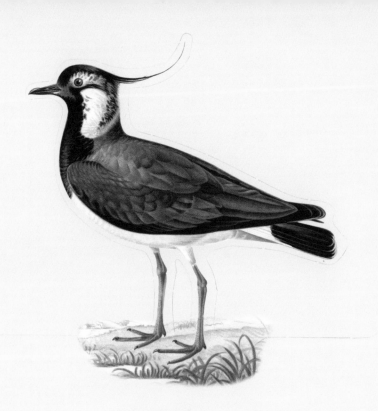

to. Best guesses are either the bird's flappy flight style or a combination of Anglo-Saxon words referring to a bobbing crest.

The call, and the song, which can resemble the electronic burbling of a detuned radio, is heard in spring when the male birds perform an aerobatic display flight, tumbling and falling almost to earth in a bid to impress females.

Nesting in a scrape on the ground makes the young vulnerable to predators so, like many waders, they are precocial—able to walk almost as soon as they hatch, and quickly able to look for the insects and small invertebrates on which they feed. Nevertheless the parents defend them devotedly, mobbing intruders by diving on them while calling shrilly, or else landing and pretending to have an injured wing, in order to entice the intruder away from the nest and young.

From late summer through to late winter, lapwings are more commonly seen in large flocks around lakes, wetlands, and estuaries, or on agricultural fields, often in the company of golden plovers and black-headed gulls.

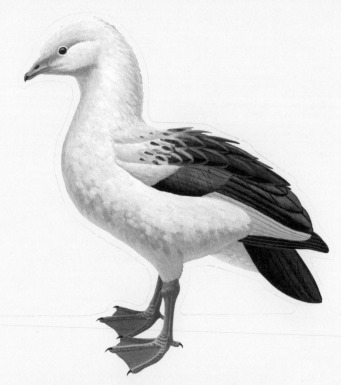

ANDEAN GOOSE

Neochen melanoptera

- - - - ◆ - - - -

LENGTH: *27½–30 in.* **WEIGHT:** *6 lb. 3 oz.–8 lb.*
WINGSPAN: *55–63 in.* **RANGE:** *western South America,*
 throughout the Andes

Around lakes and marshes in the high Andes of South America, from Peru southward, pairs or small family groups of this handsome species graze on grasses, sedges, and aquatic plants, usually at well over 10,000 feet above sea level.

Strictly speaking, it's a shelduck rather than a goose, being particularly closely related to the Orinoco goose, as well as four South American sheldgoose species, but whatever its lineage (and there may be new discoveries yet to be made about its taxonomy), it's easily recognizable by its smart black and white plumage and its tiny (for a goose) pink bill.

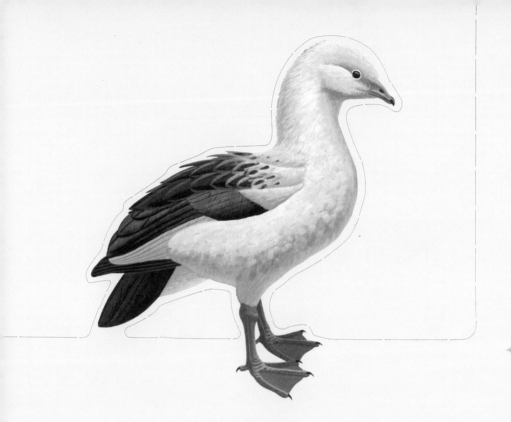

Unusually among geese, it's not much of a swimmer and usually only takes to the water when danger is absolutely imminent.

Nests are built in shallow depressions in the ground, or occasionally in rock crevices, and lined with plant material. They're not necessarily by the water's edge, but soon after hatching, the parents take the goslings down to the water in order to be able to escape predators easily. Males defend both nest and young vigorously and noisily, while females will also join in to defend the nest site.

The geese can remain in families for some time, until bigger groups gather at the onset of winter. Large flocks tend to form outside the breeding season, performing short-term movements to lower altitudes to escape heavy snowfalls and other bad weather.

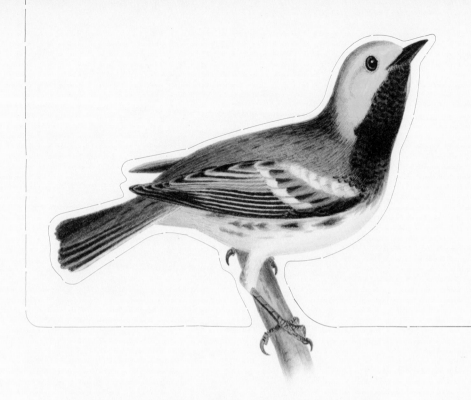

BLACK-THROATED
GREEN WARBLER

Setophaga virens

--- --- ◆ --- ---

LENGTH: *4 in.* **WEIGHT:** *¼–½ oz.*

WINGSPAN: *7–8 in.* **RANGE:** *eastern North America;*
winters in Central America,
Colombia, Venezuela

Any visit to the conifer forests of eastern Canada and the United States in spring or summer is likely to be soundtracked by this tiny but astonishingly persistent songster.

One male was recorded singing 466 songs in an hour, but despite the astonishing energy and dedication displayed, there's precious little variation from one ditty to the next. A "zee zee zee zoo zee" song

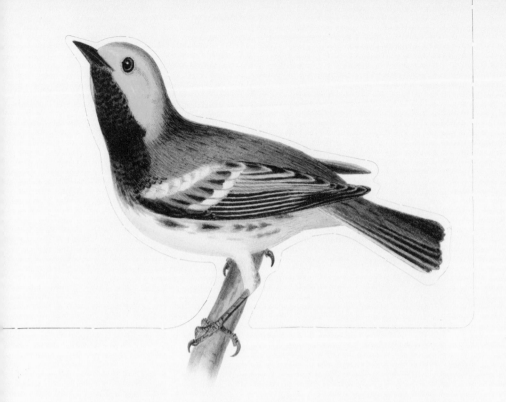

is performed from the middle of its territory early in the breeding season, in a bid to attract females, while a "zoo zee zoo zoo zee" song is belted out at the breeding territory's edges, in a warning to rival males to stay away.

If that's not enough to make it an easy bird to identify, its bright-yellow face and black bib are distinctive among birds in its range. Other than a few berries in winter, it feeds largely on insects, which may be hawked in flight, gleaned from branches as the bird hovers, or foraged from vegetation.

As well as conifers, mixed woodland is sometimes used for breeding, with an open-cup nest being built close to a tree trunk. There is also a subspecies of black-throated warbler that breeds in the cypress swamps of coastal Virginia and the Carolinas, considerably lower in altitude than its usual haunts.

Although it is sometimes parasitized by the brown-headed cowbird, which lays its eggs in the warbler's nest, cuckoo-style, the black-throated green warbler is an abundant breeder facing no immediate conservation concerns, with populations stable since the 1960s.

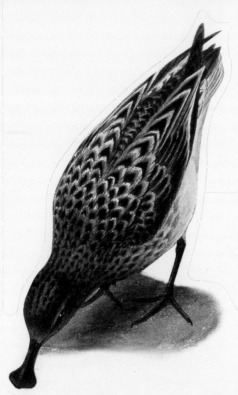

SPOON-BILLED
SANDPIPER

Calidris pygmaea

- - - - - ◆ - - - -

LENGTH: *5½–6½ in.* **WEIGHT:** *1–1¼ oz.*

WINGSPAN: *16½–19 in.* **RANGE:** *Far Eastern Russia, winters
in Southeast Asia*

This unusual wading bird may be the least typical member of its family. It is named for its most noticeable feature, which it swings from side to side through shallow water and estuary mud as it walks, in the manner of the unrelated spoonbill (a relative of the herons and egrets), taking tiny worms, crabs, and gastropods, as well as insects, larvae, and seeds in summer.

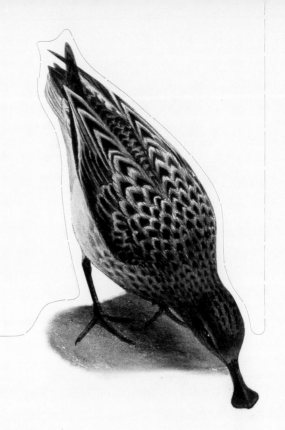

Breeding in extreme northeast Russia, it undertakes a migration to Southeast Asia for the winter, but loss of breeding habitat, the draining of tidal flats on stopover sites in its migratory range, and hunting of it in Burma have been a triple whammy that has rendered it almost extinct, with less than 2,500 individuals now thought to be left in the wild. The fact that it is very faithful to traditional wintering sites makes it particularly vulnerable.

In recent years, intensive conservation efforts have given cause for cautious hope for the species. As well as attempts to preserve habitats, and to educate hunters about the long-term effects of their actions, there has been a groundbreaking captive breeding program based at the Wildfowl and Wetlands Trust's Slimbridge reserve in the United Kingdom. It is hoped that significant numbers of the birds can be raised there, then re-released into the wild, but the success of the scheme will ultimately depend on the ongoing threats to the species's survival being removed or at least mitigated.

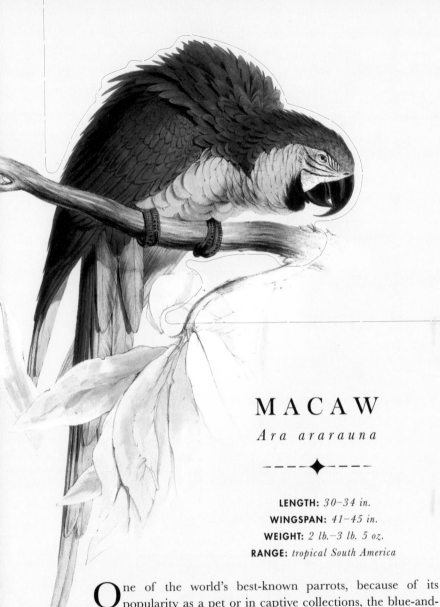

MACAW

Ara ararauna

- - - ◆ - - -

LENGTH: *30–34 in.*
WINGSPAN: *41–45 in.*
WEIGHT: *2 lb.–3 lb. 5 oz.*
RANGE: *tropical South America*

One of the world's best-known parrots, because of its popularity as a pet or in captive collections, the blue-and-yellow macaw is also one of the larger members of the family. The zebra-striping around the eye is distinctive, but the bare white face can turn pink when the bird is excited.

In its natural range, which extends slightly into Central America (introduced birds have also bred in Puerto Rico and Florida), it is typically found in both flooded and dry forests, as well as in palm

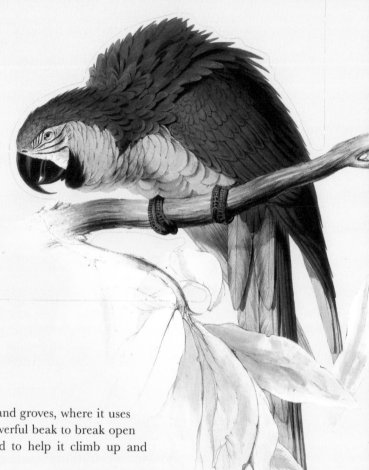

plantations and groves, where it uses
its large, powerful beak to break open
nutshells and to help it climb up and
down trees.

Dead palms are usually used for nesting in,
with the bird usually mating for life—it can live
for up to 35 years in the wild.

But family life among the macaws is not quite as
heartwarming as it sounds. While two or three eggs are
laid, after they are hatched the parents quickly focus all of
their attention on one dominant nestling, with the others left
to starve to death. This, in fact, is a strategy used by many birds, to
maximize the use of food resources.

Its ability to learn human speech, and willingness to bond with
humans, made it a popular bird as a pet historically, but—although it
is in danger of being lost from parts of its range, notably Paraguay—it
remains relatively abundant and widespread.

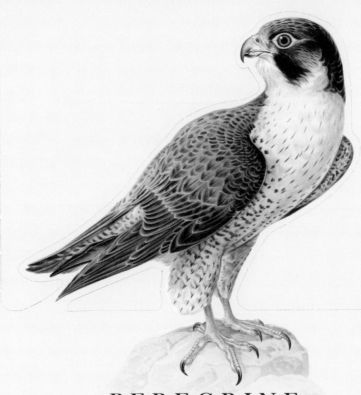

PEREGRINE

Falco peregrinus

------◆------

LENGTH: *13½–23 in.* **WEIGHT:** *12 oz.–3 lb. 5 oz.*

WINGSPAN: *29–47 in.* **RANGE:** *worldwide in suitable habitat, but large gaps occur*

The fastest creature on the planet, the peregrine is also the most widespread bird of prey in the world, with as many as 19 subspecies recognized. But in many parts of the globe, persecution as well as the indirect effects of pesticides passed up through the food chain wiped it out at an alarming rate, until recent conservation efforts improved its fortunes.

Its maximum recorded speed—242 miles per hour—occurred during the final stoop used when hunting. The peregrine typically drops onto

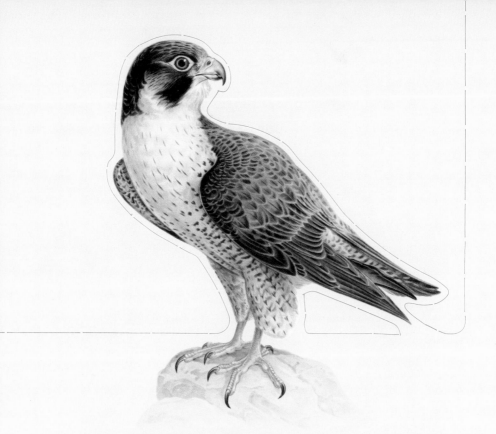

avian prey from above, balling its talons into fists to break the neck, then catching the victim before it hits the ground. Some birds are caught in level flight, or even snatched from perches.

One reason for this adaptation of hunting methods is the variety of habitat used by the bird. A cliffnesting species, the peregrine was historically an upland breeder, moving to warmer, prey-rich areas such as coastal salt marshes in winter. But in Europe and North America especially, recent decades have seen it move into city centers and lowland quarries, where the manmade environment mimics its natural home, and where plentiful supplies of prey occur.

Studies have shown that such peregrines even hunt by night, using the upglow of street lighting to take migrating species as they fly over, and that while pigeons of all sorts remain a favorite prey, an astonishingly wide range of species are eaten, up to the size of a Canada goose.

Always popular with falconers, the peregrine was reintroduced in the eastern United States largely using former captive stock from several subspecies, effectively creating a new subspecies altogether.

DUNNOCK

Prunella modularis

- - - ◆ - - -

LENGTH: *5–5½ in.* **WEIGHT:** *½–1 oz.*
WINGSPAN: *7½–8 in.* **RANGE:** *Eurasia, parts of the Middle East, introduced into New Zealand*

Once commonly called the hedge sparrow, the dunnock is now more often known by its older, and considerably more accurate, English name, meaning "small, dingy-brown creature," a pretty accurate description of the bird's unremarkable plumage, which also avoids perpetuating the confusion that it is in some way related to the house sparrow.

In fact, it's an accentor, a member of a small family of birds otherwise restricted to upland habitats. The dunnock, however, prefers lowlands, particularly hedgerows and woodland, plus parks and backyards, where it feeds on the ground on insects and spiders, as well as seeds and berries

in winter. It has also taken to visiting backyard feeders, usually waiting underneath to pick up fallen peanut granules or suet pellets.

Both it and its sweet, warbling song are often mistaken for other species by backyard birdwatchers, but the dunnock does have one attention-grabbing feature—its extremely convoluted sex life. Females often practice polyandry (breeding with two or more males at once), and males anxious to ensure their own success sometimes peck at the cloaca of a female in order to stimulate the ejection of a rival male's sperm. Given that dunnocks can mate up to 100 times each day, that leaves plenty of scope for complications, and many broods have more than one father. In such cases, both males may provide food to the female and her young.

Depending on overlap of territories, security of food supply, monogamy, and polygynandry (two males jointly defending a territory containing multiple females) are also used on occasion, but all have helped make the dunnock a widespread and numerous bird.

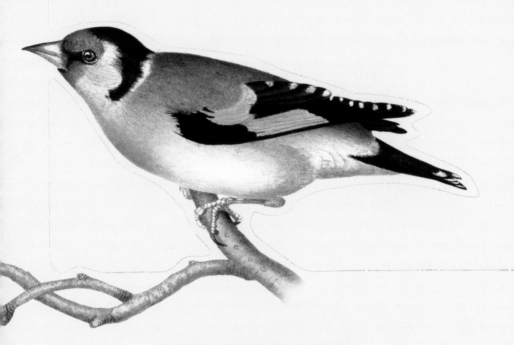

GOLDFINCH

Carduelis carduelis

- - - - ◆ - - - -

LENGTH: *5–5½ in.* **WEIGHT:** *½–¾ oz.*
WINGSPAN: *8½–10 in.* **RANGE:** *Western Europe, North Africa, Middle East, Asia*

It would be easy to think that the collective noun for this species—a "charm"—refers to the beauty of its delicate build, bright-red face and yellow wing flashes, but in fact the goldfinch is derived from an Anglo-Saxon word—*cirm*—describing the gentle tinkling sound made by a roving flock of the birds.

Such flocks have become a far more common sight in many parts of Europe, particularly Britain, in recent decades, as the goldfinch has supplemented its preferred natural diet of thistle and teasel seeds (its scientific name is derived from the Latin for thistle) with food from

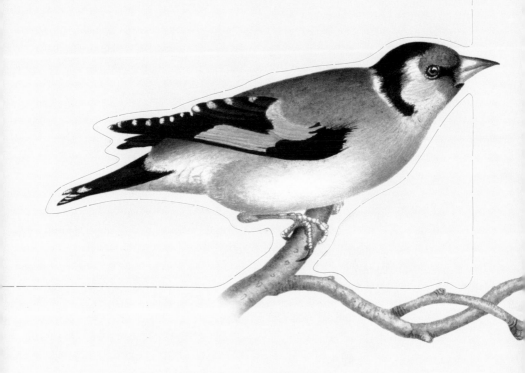

backyard feeders, especially black nyjer or niger seeds and sunflower seeds. It has also, over the last century or so, benefited greatly from no longer being taken in huge numbers for the cage-bird trade. That had made it virtually extinct in parts of Britain and Europe by the start of the twentieth century; its recovery began following the implementation of legal protection.

Because of its connection with thistles, the goldfinch was used by Renaissance artists as a Christian symbol, specifically of Jesus's crown of thorns and Jesus and Mary's foreknowledge of the Crucifixion.

Away from the backyards that have become such an important part of its habitat, it is a bird of open, partially wooded lowlands, and although many in the east of its range migrate to warmer areas in winter, in western Europe it is largely sedentary. It has also been introduced into the Americas, South Africa, and Australasia, and has thrived across much of these areas.

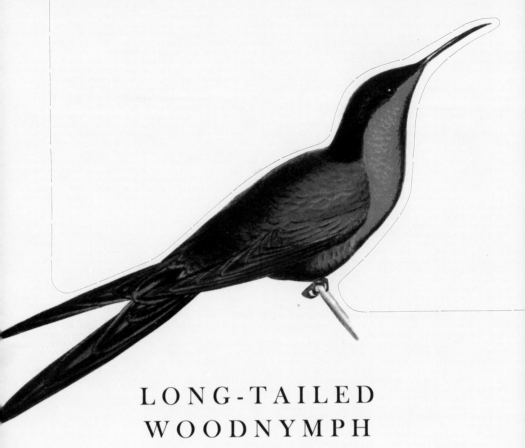

LONG-TAILED
WOODNYMPH

Thalurania watertonii

— — — ◆ — — —

LENGTH: *4–5 in.* **WEIGHT:** *c. ¹⁄₆ oz.*

WINGSPAN: *4–4½ in.* **RANGE:** *coastal northeastern Brazil*

Part of a hummingbird family that forages for nectar in the understorys of forests, or around the edges of patches of woodland, the long-tailed woodnymph is, as you might expect, best distinguished by its long and deeply forked tail.

The almost straight, mid-length bill is used for extracting nectar from flowers, while small insects are also sometimes eaten, and form the bulk of the diet of nestlings. As with many hummingbirds, the males can be extremely aggressive about defending their territories

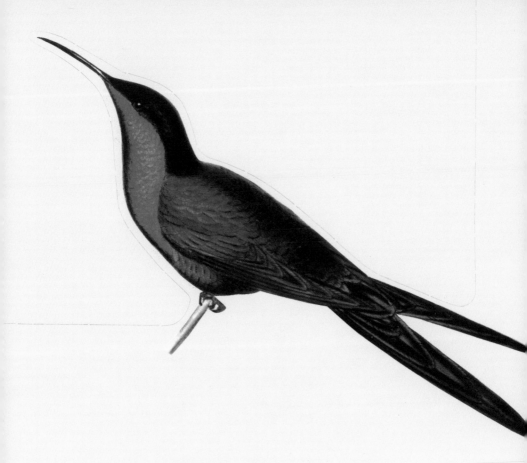

and food sources from other birds and even large insects.

It is one of the rarest hummingbirds in the world, with perhaps no more than 2,500 individuals in existence, making its long-term survival precarious if there is large-scale destruction of its preferred habitats —coastal rainforest, *cerrado* (a sort of tropical savannah), plantations, and parks. It is willing to adapt to more man-made environments if sufficient forest or stands of trees remain nearby, and birds do wander to a certain extent in search of flowering plants, but there is a worrying long-term if slow decline in its population.

Its nest, like that of many hummingbirds, is a bowl made of roots, fine twigs, and moss, all held together by cobwebs, and perched on a horizontal branch in a large shrub or small tree.

The iridescent green and violet-blue coloring of the male is common to all the eight species of the woodnymph family, which is distributed throughout Central and South America.

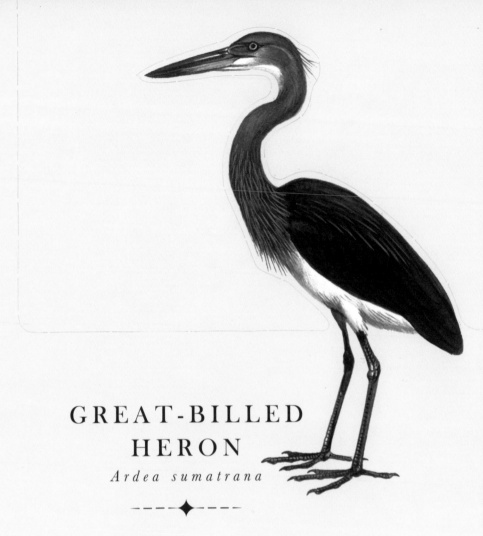

GREAT-BILLED
HERON

Ardea sumatrana

— — — ◆ — — —

LENGTH: *43–47 in.* **WEIGHT:** *4 lb. 14 oz.–5 lb. 2 oz.*
WINGSPAN: *73–90 in.* **RANGE:** *Southeast Asia, from India to northern Australia*

Unlike some heron species, this is a bird very often restricted to coastal habitats—islands, coral reefs, mangrove swamps and the estuaries of large rivers. Indeed, its large nest, built of sticks, is usually sited deep in a mangrove thicket. It is, however, occasionally found on inland pools and rivers too, but is yet to become as tolerant of the presence of man as some members of its family, such as the gray heron.

Like most herons, it feeds by wading or standing absolutely motionless in

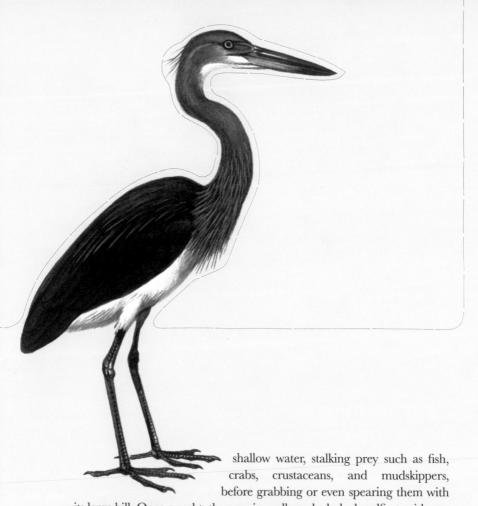

shallow water, stalking prey such as fish, crabs, crustaceans, and mudskippers, before grabbing or even spearing them with its large bill. Once caught, the prey is swallowed whole, headfirst, with any indigestible parts regurgitated in the form of a pellet, in the manner of many raptors and owls.

As with all herons, the process of hunting in water is a difficult one, as the refractive effect of the water makes judging exact location and distance particularly tricky. To get around this, the bird moves its head back and forth, and from side to side, a number of times before making its lunge at the prey, effectively improving its binocular vision and triangulating the exact location of the food object.

Again in common with all its family, it flies slowly but strongly on large "fingered" wings, and with its neck retracted, the latter feature making it easily distinguishable from similar-looking species such as storks and cranes.

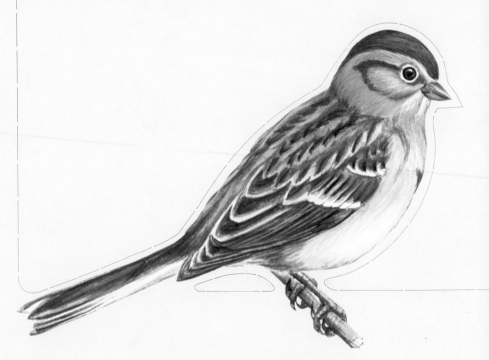

AMERICAN
TREE SPARROW

Spizella arborea

— — — ◆ — — —

LENGTH: *5–6 in.* **WEIGHT:** *½–1 oz.*
WINGSPAN: *12–14 in.* **RANGE:** *Canada, northern United States; migrating to Central America in Winter*

This is another of those species saddled with a misleading name, because it is predominantly a ground bird, but reminded European settlers of the Eurasian tree sparrow on account of its chestnut-brown cap, the most distinctive feature of its otherwise rather dull brown and gray plumage. Just to confuse things further, it has been traditionally classed as part of the American sparrow genus *Spizella*, whose members are in fact more closely related to Old World buntings than sparrows,

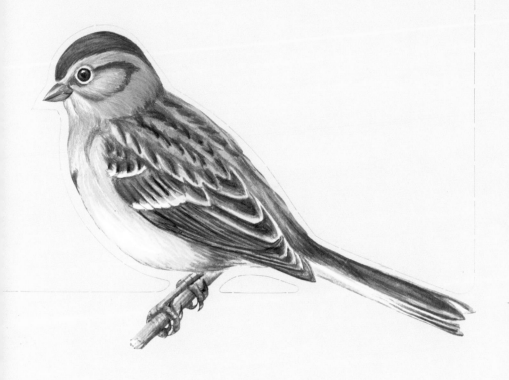

but recent DNA evidence suggests that it may belong in a genus all of its own.

It breeds on the high tundra and forest edges of the extreme north of North America, so for a large part of the year has little contact with humans, but in winter it moves south, migrating by night, often in large flocks, with females wintering at more southerly latitudes than the males. This movement is the reason for its alternative name—winter sparrow.

At this time of year, it becomes a familiar bird even as far south as Texas, foraging on the ground for berries and seeds, and sometimes hanging around backyard feeders in the company of species such as dark-eyed juncos (*Junco hyemalis*). And the search for food is constant —the American tree sparrow needs to eat around 30 percent of its bodyweight in food each day.

Back on their breeding grounds, the females lay 4–6 eggs at the rate of one a day, but all hatch within a few hours of each other, so that the youngsters can fledge and start foraging at the same time.

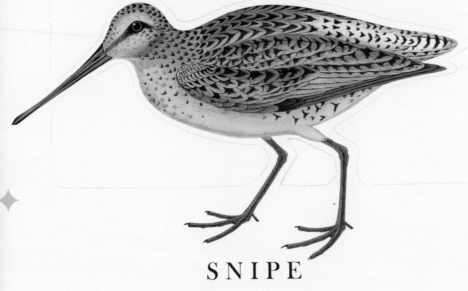

SNIPE

Gallinago gallinago

- - - ◆ - - -

LENGTH: *10–11 in.* **WEIGHT:** *3–6½ oz.*
WINGSPAN: *17–18½ in.* **RANGE:** *Europe, Asia, North Africa*

For much of the year, the snipe (also known as the common snipe) is a largely anonymous bird, its streaked brown plumage helping it blend into its typical habitat of marshes, bogs, and damp meadows, as well as lake margins, ditches, and even seashores in winter. It eats worms and insects, as well as a small amount of vegetation, picking the former from the mud with its straight bill, which can be as long as 2¾ in.

At such times, what is after all a stocky and reasonably large wader can stay hidden almost until it is trodden on, at which point it flushes vertically with a squelching "ca-aaatch" alarm call, before flying away extremely rapidly on a zigzag course. The skill needed to shoot the

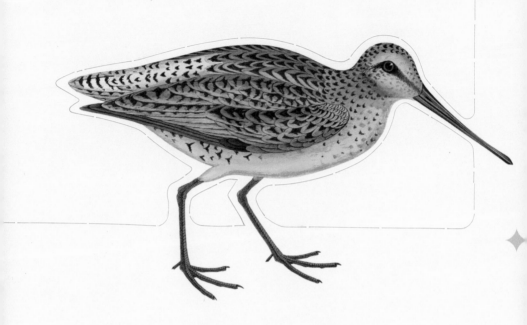

birds in such circumstances—and, like many waders, they were once much hunted for the pot—gave us the word "sniper."

In spring and early summer, however, male snipe engage in a quite different kind of flight, displaying to females. This involves circling their territories, then making shallow dives during which they're accompanied by a bleating sound. But the "drumming," as it's known, isn't a call at all: it's made by the vibration of outer tail feathers, held at 90 degrees to the direction of flight. In far northern areas where breeding snipe are numerous, such as Iceland, this remarkable sound can be heard nonstop throughout the 24-hour midsummer daylight.

The similar North American species, Wilson's snipe, was once considered a subspecies of common snipe, but has now been split to form a species of its own.

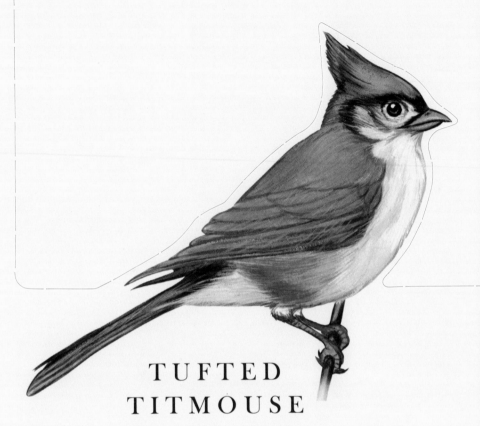

TUFTED
TITMOUSE

Baeolophus bicolor

◆ – – – ◆ – – –

LENGTH: *5½–6½ in.* **WEIGHT:** *½–1 oz.*
WINGSPAN: *8–10 in.* **RANGE:** *eastern USA, a few in*
southeastern Canada

Like most of the tit and chickadee family, this is a bird of deciduous and mixed woodland that has readily adapted to the backyards and parks of towns and cities.

In the latter habitats, the tufted titmouse exhibits a strangely split personality. On the one hand, it is a nervous visitor to backyard feeders, usually grabbing a seed while other birds are absent and retiring into dense cover to eat it. Insects, insect eggs and pupae, and caterpillars all

form an important part of the diet, also, gleaned from vegetation by the sort of acrobatic foraging typical of the tit family.

On the other hand, it's a species that can be extremely curious about humans, perching on window ledges to peer into windows.

The titmouse usually nests in a hole in a tree, either a natural cavity or an old woodpecker hole, and will also take to man-made nest boxes readily. It lines the nest with soft material, which can even include hair plucked from live animals, such as pet dogs.

The young—up to nine in each brood—are fed by both parents after an initial period in which the female stays at the nest and the male supplies all with food. Sometimes the pair are helped by a third bird, one of the previous year's youngsters that has not paired up with a mate of its own.

Backyard feeding may have helped the species expand its range northward in recent decades, and has certainly helped alleviate the need for it to migrate to warmer climes in winter—populations are now typically sedentary. Its call, usually transcribed as "peter peter," is distinctive.

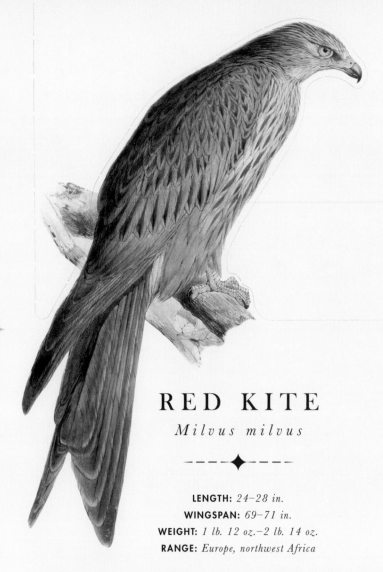

RED KITE

Milvus milvus

- - - - ◆ - - - -

LENGTH: *24–28 in.*
WINGSPAN: *69–71 in.*
WEIGHT: *1 lb. 12 oz.–2 lb. 14 oz.*
RANGE: *Europe, northwest Africa*

This is a supremely elegant bird of prey, soaring on long wings held in a shallow V while using its long, deeply forked tail as a rudder. In areas where it is common, sunny days can see "kettles" of a couple of dozen circling patiently as they survey the ground below for feeding opportunities.

It isn't, however, much of a hunter. Although a few live small mammals, birds, reptiles, and amphibians are taken, it is predominantly a scavenger that eats carrion, while earthworms and, increasingly, human waste, also form an important part of the diet.

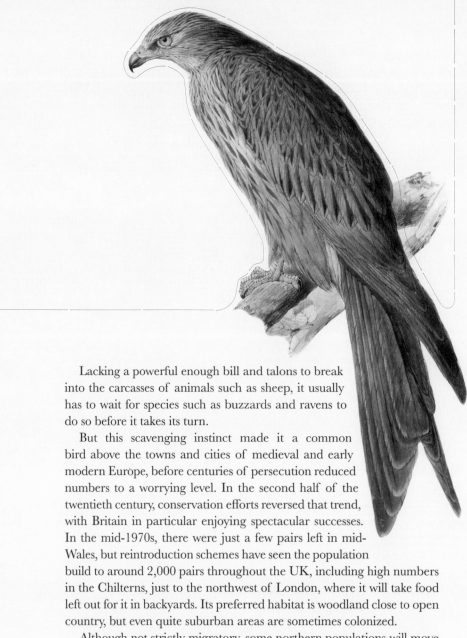

Lacking a powerful enough bill and talons to break into the carcasses of animals such as sheep, it usually has to wait for species such as buzzards and ravens to do so before it takes its turn.

But this scavenging instinct made it a common bird above the towns and cities of medieval and early modern Europe, before centuries of persecution reduced numbers to a worrying level. In the second half of the twentieth century, conservation efforts reversed that trend, with Britain in particular enjoying spectacular successes. In the mid-1970s, there were just a few pairs left in mid-Wales, but reintroduction schemes have seen the population build to around 2,000 pairs throughout the UK, including high numbers in the Chilterns, just to the northwest of London, where it will take food left out for it in backyards. Its preferred habitat is woodland close to open country, but even quite suburban areas are sometimes colonized.

Although not strictly migratory, some northern populations will move south in response to particularly bad winter weather, and young, unpaired birds often roam far and wide in early spring. Where their range overlaps, it very occasionally hybridizes with black kites.

RUFFED GROUSE

Bonasa umbellus

- - - ◆ - - -

LENGTH: *16–20 in.*
WINGSPAN: *20–25 in.*

WEIGHT: *1 lb.–1 lb. 10 oz.*
RANGE: *northern North America, from the Appalachians westward*

This medium-sized grouse is common and widespread in forested areas across much of northern North America, and is the only member of its genus. That individuality is displayed in both its looks and its behavior.

It appears rather slimmer than most other grouse, and both males and females have the black ruffs which give the species its name on the sides of their necks, although only males display them. Its small triangular crest and fan-shaped tail are also distinguishing features.

Living in mixed forests with scattered clearings, it forages on the ground

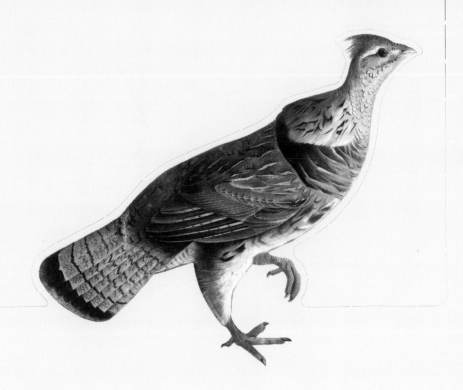

or low down in trees for a wide variety of foods, including bitter, toxic, and fibrous plant matter that other birds can't eat, as well as buds, seeds, berries, insects and small animals, and reptiles on occasion. This catholic diet is one reason for its abundance, which hasn't been threatened by it being a popular game bird.

The ruffed grouse's courtship display is also unlike that of other grouse, with the male beating his wings rapidly to produce a low-frequency drumming sound, often compared to a car trying to start, that can be heard far afield.

It's a shy bird, so the best chance of seeing one is by staking out one of the sites (often large logs) from which the display is performed, or looking along the edges of forest roads early in the morning, when it shakes off some of its caution as it searches for food. It dust-bathes regularly on such roads, too, so during dry periods it can often be found on verges.

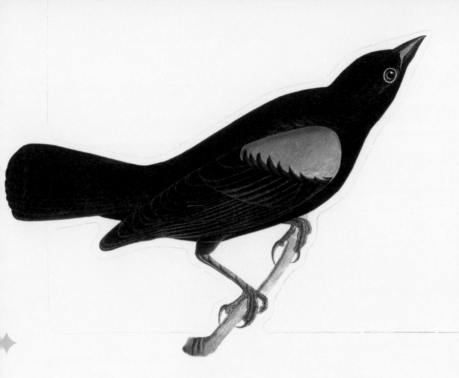

RED-WINGED
BLACKBIRD

Agelaius phoeniceus

- - - ◆ - - -

LENGTH: *7–9½ in.* **WEIGHT:** *1–3 oz.*
WINGSPAN: *13½–16 in.* **RANGE:** *North America, Mexico*

Despite the name, this North and Central American species is no relation to the celebrated backyard songster of the Old World, instead being part of a wider family that includes orioles, meadowlarks, grackles, and cowbirds.

It may well be the most abundant land bird in North America, with a population of more than 250 million in peak years, plus loose winter flocks that can exceed a million birds. Even if surpassed by the likes of starlings, it is a ubiquitous sight in open grassy areas, and while it

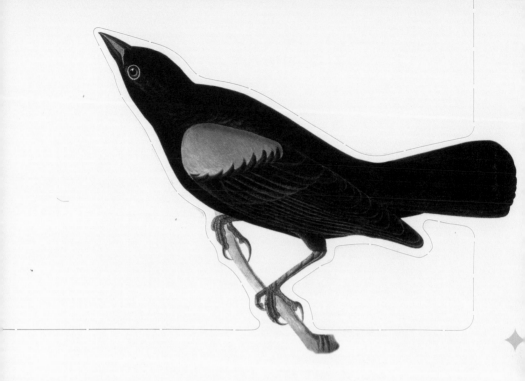

shows a preference for wetlands, it can also be found in upland meadows and prairies.

Birds living in the northern part of its range migrate south in winter, but many populations are sedentary, making only local movements in response to food shortages.

Its abundance and success in adapting to varying habitats is at least in part due to its omnivorous diet, which includes weed seeds, grain, insects, spiders, molluscs, frogs, eggs, carrion, and fruit. This has also seen it labeled as an agricultural pest at times, although attempts to control it using pesticides are illegal in the United States.

While its scratchy song is no match for that of its European namesake, it is similarly well known even to nonbirdwatchers because of its aggressive defense of its breeding territory from potential predators— even humans who get too near the nest are likely to be swooped at repeatedly. In part this is due to the fact that the species is predated by so many others—hawks of the *Buteo* and *Accipiter* genuses, and falcons. A range of mammals, reptiles, and birds from herons to marsh wrens also predate the eggs, so an extra precaution taken by red-winged blackbirds involves nesting in loose colonies.

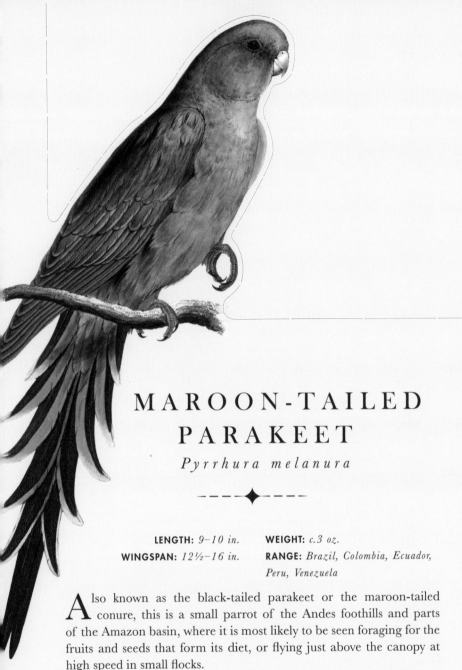

MAROON-TAILED PARAKEET

Pyrrhura melanura

--- ◆ ---

LENGTH: *9–10 in.* **WEIGHT:** *c.3 oz.*
WINGSPAN: *12½–16 in.* **RANGE:** *Brazil, Colombia, Ecuador,*
Peru, Venezuela

Also known as the black-tailed parakeet or the maroon-tailed conure, this is a small parrot of the Andes foothills and parts of the Amazon basin, where it is most likely to be seen foraging for the fruits and seeds that form its diet, or flying just above the canopy at high speed in small flocks.

It is a lowland and temperate-cloud-forest species, and is tolerant of secondary forest, also showing a preference for woodland edge and partly

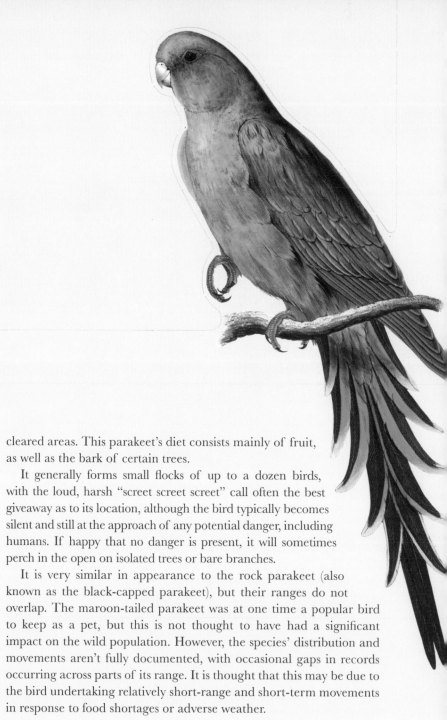

cleared areas. This parakeet's diet consists mainly of fruit, as well as the bark of certain trees.

It generally forms small flocks of up to a dozen birds, with the loud, harsh "screet screet screet" call often the best giveaway as to its location, although the bird typically becomes silent and still at the approach of any potential danger, including humans. If happy that no danger is present, it will sometimes perch in the open on isolated trees or bare branches.

It is very similar in appearance to the rock parakeet (also known as the black-capped parakeet), but their ranges do not overlap. The maroon-tailed parakeet was at one time a popular bird to keep as a pet, but this is not thought to have had a significant impact on the wild population. However, the species' distribution and movements aren't fully documented, with occasional gaps in records occurring across parts of its range. It is thought that this may be due to the bird undertaking relatively short-range and short-term movements in response to food shortages or adverse weather.

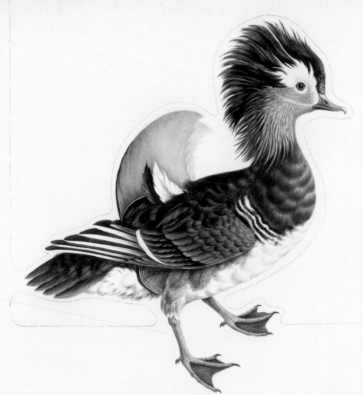

MANDARIN DUCK

Aix galericulata

- - - - ◆ - - - -

LENGTH: *16–19 in.* **WEIGHT:** *15 oz.–1 lb. 8 oz.*
WINGSPAN: *26–30 in.* **RANGE:** *East Asia; introduced into western Europe, USA*

The introduction of non-native species into an ecosystem is fraught with dangers for the native wildlife, but occasional happy accidents occur, and the mandarin duck is one.

In its original East Asian home, it has suffered serious decline as its habitat has been destroyed—mandarins are hole-nesters that live in forest and woodland. While several thousand are still found in Japan, the species has struggled recently in Russia, China, and the two Koreas.

But at least 7,000 can now be found in Britain, having formed a self-supporting population after escaping from wildlife collections,

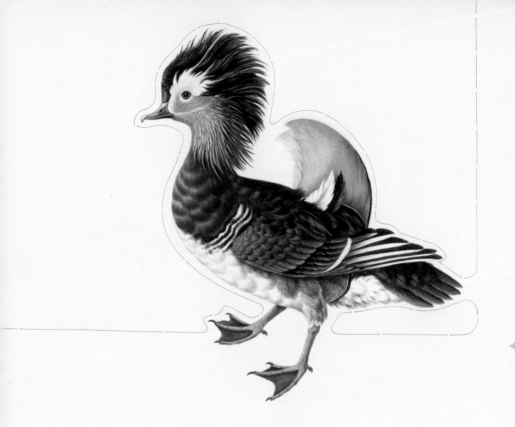

and other parts of Europe also have significant numbers, with a large population living in and around Berlin, for example. These introduced birds typically live in more open habitat than in the home range, although still requiring shallow lakes surrounded by or near plenty of tree cover, and there is little sign that they have adversely affected any of the native birds. Their diet, of seeds, plants, and smaller amounts of snails, insects, and fish, is similar to that of other dabbling ducks.

Despite the male duck's colorfully ornate appearance, it can be remarkably difficult to see even at sites where it's known to live, partly because of a preference for staying tucked into the edges of lakes, hidden by overhanging branches. In addition, the male's eclipse plumage after moulting is, as with most ducks, much duller than its breeding finery. Because of this, sightings can often be fleeting, if memorable, with pairs flushed from small woodland pools or streams.

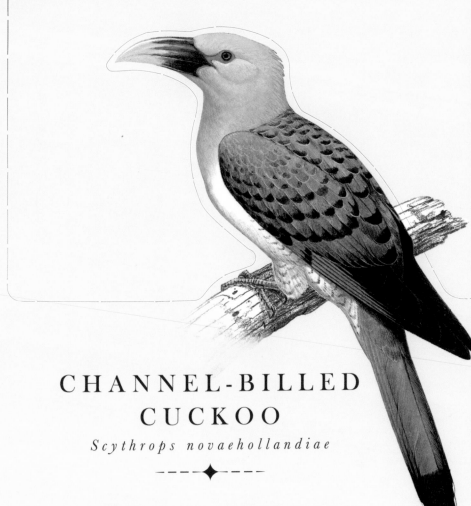

CHANNEL-BILLED
CUCKOO

Scythrops novaehollandiae

---◆---

LENGTH: *23–26 in.*
WINGSPAN: *35–40 in.*

WEIGHT: *1 lb. 3 oz.–2 lb. 1 oz.*
RANGE: *Australia, Papua New Guinea, Indonesia; vagrant to New Zealand, New Caledonia*

The largest cuckoo and the largest brood parasite in the world, the channel-billed cuckoo is unusual among its immediate family in that it feeds mainly on fruits, especially figs, found in the rainforest canopy. Insects are also eaten, as well as the eggs and nestlings of some smaller birds.

It is strongly migratory, wintering in New Guinea and Indonesia then crossing to Australia in small groups, and occasionally much larger flocks,

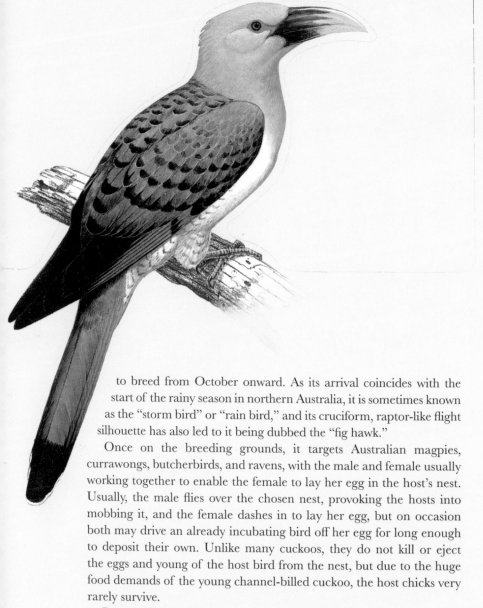

to breed from October onward. As its arrival coincides with the start of the rainy season in northern Australia, it is sometimes known as the "storm bird" or "rain bird," and its cruciform, raptor-like flight silhouette has also led to it being dubbed the "fig hawk."

Once on the breeding grounds, it targets Australian magpies, currawongs, butcherbirds, and ravens, with the male and female usually working together to enable the female to lay her egg in the host's nest. Usually, the male flies over the chosen nest, provoking the hosts into mobbing it, and the female dashes in to lay her egg, but on occasion both may drive an already incubating bird off her egg for long enough to deposit their own. Unlike many cuckoos, they do not kill or eject the eggs and young of the host bird from the nest, but due to the huge food demands of the young channel-billed cuckoo, the host chicks very rarely survive.

Recent decades have seen this cuckoo thriving, probably due to increases in its host species around Australian towns and cities—planting of backyards there may also have increased the food available to it.

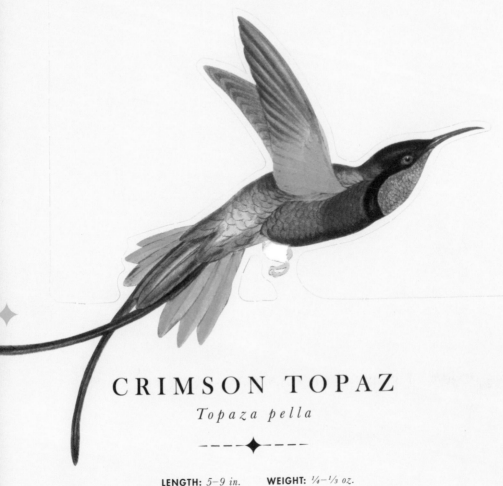

CRIMSON TOPAZ

Topaza pella

- - - ◆ - - -

LENGTH: *5–9 in.* **WEIGHT:** *¼–⅓ oz.*
WINGSPAN: *6–7 in.* **RANGE:** *Brazil, Colombia, Guyana, French Guiana, Peru, Surinam, Venezuela*

The crimson topaz is thought to be the second-largest hummingbird in the world, and certainly within its home range it has no equal; only the giant hummingbird, found in the Andes, bests it. Nonetheless, it is, like most hummingbirds, a diminutive species, and as it spends most of its time in the middle and higher canopy of lowland forests in tropical South America, it isn't an easy bird to see.

Also like most hummingbirds, it feeds largely on nectar, hovering next to a flower and using its long, extendable tongue to lap it up.

It particularly favors the flowers with the highest sugar content, and is aggressively territorial in defense of its food sources, chasing away not only other birds but also large insects such as bumblebees and hawk moths. However, some of the tubular flowers it likes cannot be visited by many bees and butterflies, ensuring that it has at least some exclusive food sources.

Insects are also taken as food for nestlings during the breeding season, a female typically capturing 2,000 or so each day to feed her hungry young. These are hawked in midflight, or snatched off branches and leaves, with the species's astonishing aerial maneuverability coming to the fore.

The iridescent crimson of the male's throat is used both to attract female birds and as a warning to rival males.

YELLOWHAMMER

Emberiza citrinella

- - - ◆ - - -

LENGTH: *6–6½ in.*
WINGSPAN: *9–11½ in.*

WEIGHT: *¾–1¼ oz.*
RANGE: *Europe, Asia; plus in winter North Africa, Middle East*

This large representative of the bunting family (a group of seed-eating small birds) has one of the most easily recognizable of all bird songs, a series of repeated short notes and a final rattling trill, often transcribed as "a little bit of bread and no cheese." So ingrained is the song in the consciousness of Europeans that it has inspired many poets, most notably Robert Burns and John Clare, as well as Beethoven, who is thought to have incorporated it into at least two of his piano concertos.

In spring, this ditty is repeated again and again from prominent perches in the habitat that the species prefers—dry farmland and open

country with plenty of hedgerows and at least some trees and bushes. Appropriately, given its color, gorse is particularly favored.

Weed seeds and grains make up most of the diet, and in winter yellowhammers may form large flocks to forage around farm buildings and grain stores. In the breeding season, some insects, caterpillars, and worms are also taken, mainly as food for the young birds, which are raised in a nest built on the ground, often on a tussock or against a bank, or low down in a hedge or bush.

Interestingly for such an attractive bird, both in terms of its chestnut and yellow coloring and its jaunty vocalizing, it once had quite an evil reputation, with the intricate pattern of lines on its eggs thought to carry messages from the Devil. They also gave rise to one of its most widespread and enduring British folk names, "scribble lark," while in Scotland and Northern Ireland it is sometimes known as the "yorlin."

It has also been introduced to Australia and New Zealand, thriving so much in the latter that it was once considered an agricultural pest.

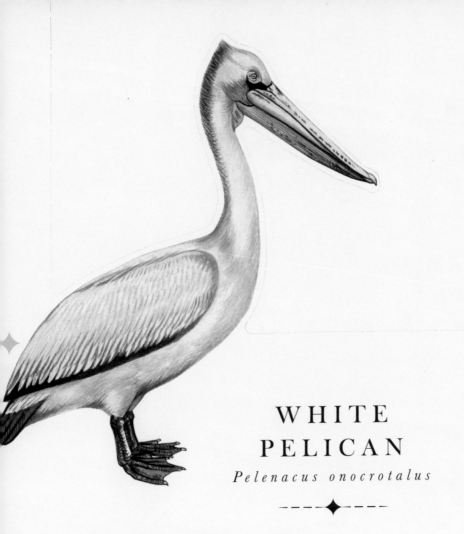

WHITE PELICAN

Pelenacus onocrotalus

--- --- ◆ --- ---

LENGTH: *55–70 in.*　**WEIGHT:** *12–33 lb.*
WINGSPAN: *90–140 in.*　**RANGE:** *southwestern Europe, Asia, Africa*

Seen on the water, with its bill pouch stuffed with fish, the great white pelican can present a somewhat comic appearance, but a soaring bird, with its huge wings outstretched (it has the largest wingspan of any bird, other than the royal albatross), is both elegant and awe-inspiring.

On migration it often flies in large flocks, sometimes V-shaped; birds that breed in the north of its range travel to more southerly climes in winter. In migration bottlenecks such as Israel, as many as 75,000 of

the birds can pass through, some lingering for
most of the winter if food is plentiful.

Reed beds around shallow warm lakes are
preferred breeding habitats, although estuaries and coastal areas are
also used, as well as marshes and other wetlands. Depending on the
area, nests are made in trees, using sticks, or on the ground, when a
scrape is lined with vegetation.

Fish form the bulk of the diet, with pelicans often hunting cooperatively
in flocks of up to 10 birds, corraling the prey into a restricted area. The
pelican is willing to travel long distances to a good food source—it will
regularly fly 50 miles from a roost to feed for the day.

However, when there's a shortage of fish, or when the needs of
feeding several hungry youngsters demand, it will also take the eggs
and chicks of other species, or even adult birds—captive pelicans in
suburban parks and zoos are notorious for snatching feral pigeons.
Other birds are also sometimes robbed of their prey.

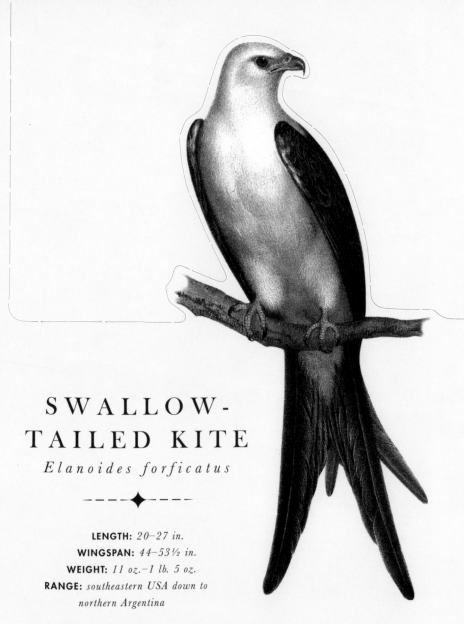

SWALLOW-TAILED KITE

Elanoides forficatus

------◆------

LENGTH: *20–27 in.*
WINGSPAN: *44–53½ in.*
WEIGHT: *11 oz.–1 lb. 5 oz.*
RANGE: *southeastern USA down to northern Argentina*

The swallow-tailed kite is among a relatively small number of bird species that belongs in a genus all of its own, and despite its name, its closest relatives are the honey buzzards and cuckoo hawks of the Old World, rather than the black-winged and black-shouldered kites, which it superficially resembles. Nor is it closely related to the African swallow-tailed kite.

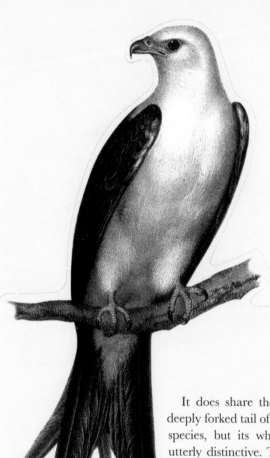

It does share the elegant proportions and deeply forked tail of the red kite, an Old World species, but its white and black plumage is utterly distinctive. Twists of that tail are used to maneuver as it soars overhead, with its long wings hardly moving at all for long periods. It often remains relatively low over treetops, but at other times will ascend almost out of sight.

Its preferred habitat is wooded wetlands, or woodlands close to water, with the bulk of its diet consisting of small snakes and lizards, amphibians, large insects, small mammals (including bats), and small birds. During the breeding season, it will also prey upon the eggs of smaller birds. Insects are usually taken on the wing, using the kite's aerobatic flying style, while animals and reptiles are snatched off trees. And, because the kite has a thicker, more robust stomach than most raptors, it can eat stinging insects, sometimes taking whole wasps' nests to plunder.

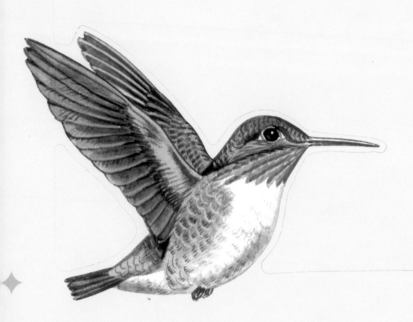

CALLIOPE HUMMINGBIRD

Selasphorus calliope

---◆---

LENGTH: *2½–4 in.* **WEIGHT:** *½ oz.*

WINGSPAN: *4⅓ in.* **RANGE:** *western North America*

That a bird weighing less than a nickel can live and breed up to 10,000 feet high in the Rocky Mountains is astonishing enough, but that it can complete a remarkable 2,500-mile migration twice a year takes the breath away as surely as the ascent to any of those aforementioned peaks.

The calliope hummingbird is the smallest breeding bird in the United States and Canada. Like all hummingbirds, it feeds mainly on nectar from flowers, gathered using its needle bill and long, extendable tongue. Its diet is sometimes supplemented with tree sap and small insects and spiders.

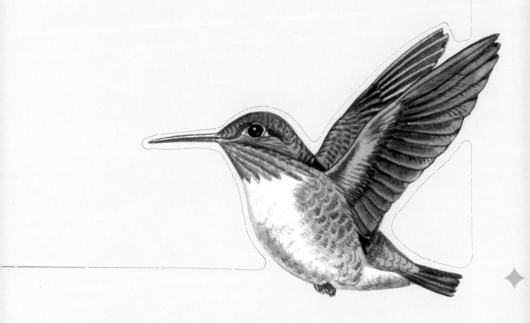

Its nomadic lifestyle is a response to these feeding preferences—from April through to late summer, it feeds and breeds in the flower-rich mountain meadows of western North America, from California right up to British Columbia and Alberta. Its nest, built in pine trees, often not only rests on a base of large pine cones, but looks somewhat similar to a pine cone itself, making the species particularly emblematic of its habitat.

In fall and winter, though, the bird heads south to Mexico, Guatemala, Belize, and other parts of Central America, to take advantage of the rich year-round vegetation there.

In the dense forests, or while on migration, it can pass unnoticed by even a keen birdwatcher. While on the breeding grounds, however, the male calliope hummingbird makes himself remarkably conspicuous for such a tiny bird, thanks to his aerobatics for the benefit of any watching females. These include U-shaped dives ending in his hovering face-to-face with the object of his attentions, and an almost insect-like buzzing noise caused by his tail feathers and the sound of wings flapping 95 times per second. A piercing, pinging call completes the remarkable performance.

Like most hummingbirds, it has suffered a recent decline due to habitat loss, but it remains a relatively common bird in its home range.

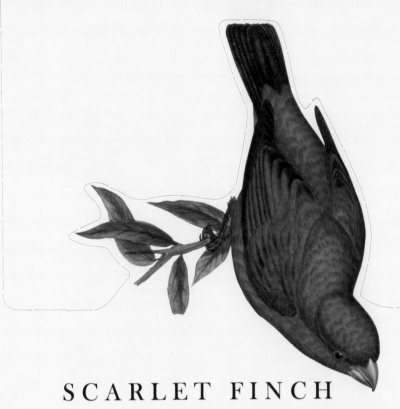

SCARLET FINCH

Carpodacus sipahi

------◆------

LENGTH: *7–7½ in.*	**WEIGHT:** *1¼–1½ oz.*
WINGSPAN: *8½–11 in.*	**RANGE:** *Southeast Asia, from the Himalayas to Vietnam and Thailand*

The male scarlet finch is one of those birds that, seen at all well, is hard to mistake for anything else, so brilliantly vivid is its coloring. The female, after the manner of many finches and small passerines, is much less colorfully marked, although with its olive-yellow tones it is still an attractive bird.

Indeed, the second part of the bird's scientific name, *sipahi*, is the Hindi word for soldier, nineteenth-century naturalists having found the male's smart red coat reminiscent of that worn by troops in British India.

It is found breeding in temperate forests, usually above 5,000 feet, preferring firs in summer but spreading to bamboo or oak in winter. Populations living at higher altitudes often move to lower ground during prolonged spells of extreme winter weather.

The scarlet finch's diet is made up of seeds, berries, small fruits, and some insects during the breeding season, at which time it may be seen both alone and in loose flocks of as many as 30. It feeds everywhere from the forest canopy to low down in undergrowth, as well as on the ground, and has a habit of perching conspicuously at the tops of trees or on bare branches. During the winter, larger flocks can form, often of a single sex.

Nowhere common, the scarlet finch is nonetheless not in any immediate conservation danger.